My Friend Van Gogh

David Zwirner Books

ekphrasis

My Friend Van Gogh
Émile Bernard

Translated by Elizabeth G. Heard
Introduced by Martin Bailey

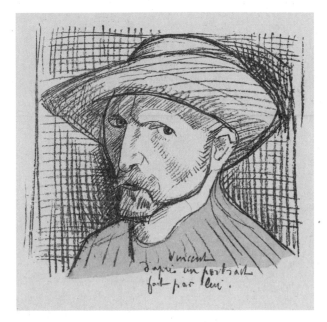

Émile Bernard, sketch of Vincent van Gogh, from the cover of *Les Hommes d'aujourd'hui*, July 1891

Contents

Introduction

Martin Bailey

It's as interesting and as difficult to say a thing well as to paint a thing. There's the art of lines and colors, but there's the art of words that will last just the same.
—Vincent van Gogh, to Émile Bernard[1]

The French artist Émile Bernard once said of Vincent van Gogh, "I was, I believe, his only close friend, after Gauguin."[2] Although Van Gogh and Paul Gauguin lived together for two months in the autumn of 1888, in Van Gogh's yellow house in Arles, they were more colleagues than friends. It was Bernard who was undoubtedly Van Gogh's closest confidant in France. Although the overwhelming majority of Van Gogh's letters are to his brother Theo, twenty-two to Bernard have survived. In some respects, Van Gogh's tone in the letters to Bernard is more informal and loose, in comparison to the manner in which he addressed his family. Tellingly, he normally started his letters to Bernard with the friendly salutation *mon cher* ("my dear"). Thanks to their lively correspondence, following Van Gogh's move to Provence, in February 1888, we have a deep insight into the connection between the two men.

The correspondence with Bernard is also vitally important for the fact that it was with a fellow artist, and one who was similarly adept with words. Although Van Gogh occasionally made sketches in his letters to Theo, he included fifteen in his letters to Bernard, nearly all of which depict his own paintings, with a view to keeping his friend informed about his work. Their exchange

throws fresh light on Van Gogh's artistic life in Arles, discussing his subject matter and style at a time when he was at the height of his powers. Bernard's numerous surviving letters to others show that he was an articulate correspondent, but, sadly, his letters to Van Gogh are lost.

In 1911, Bernard published, with the Parisian art dealer Ambroise Vollard, Van Gogh's letters in *Lettres de Vincent van Gogh à Émile Bernard*. This volume, which included a lengthy preface and four of Bernard's earlier writings on Van Gogh, appeared twenty-one years after Van Gogh's death, when the Dutchman was winning larger recognition but before he achieved international fame. Sometimes Bernard's details are not quite correct, and at other times he certainly exaggerates the importance of his own art and role, but I would argue that he is a relatively reliable source on Van Gogh. Among those who knew Van Gogh, beyond his sister-in-law Jo Bonger, Bernard has recorded by far the most detailed and important memories. The present publication provides the first full English translation from the original French of Bernard's personal recollections of his friend.[3] In contrast to the 1911 volume, Bernard's five texts are here published in the order in which they were written, clarifying the evolution of his ideas.

*

* *

Bernard first published extracts of the letters he received from Van Gogh in the monthly journal *Mercure de France* between April and July 1893, with an accompanying preface (pp. 36–45).[4] The publishing arrangements were made just before he set off on a trip in March that year which eventually led him to Egypt, where he then lived for a decade.

Bernard first stopped in Florence, where he began a second preface (pp. 46–51) for the *Mercure de France*, to introduce Van Gogh's letters to Theo, on loan from Van Gogh's sister-in-law Jo. He then journeyed to Constantinople and to the Greek island of Samos, where he decorated the chapel of a French monastery. From Samos he set off on a pilgrimage to Jerusalem, probably still with Van Gogh's letters to Theo in hand, and then traveled to Jaffa to catch a ship to Alexandria. In October 1893, Bernard reached Cairo, where he settled in the Egyptian quarter and adopted the local dress. He soon met a young Lebanese woman, Hanénah Saati, whom he married the following year. In 1895, he tried but failed to publish a selection of letters from Van Gogh in a dedicated volume, for which he wrote an introduction (pp. 52–58).

Saati left Bernard in 1903, and a few months later he returned to France, which would remain his home for the rest of his life. He kept his letters from Van Gogh until the late 1920s, when, presumably strapped for cash, he sold them. They were bought by Baroness Marianne Goldschmidt-Rothschild, a German member of the European banking dynasty and a collector of impressionist

and modern art. Count Harry Kessler recorded a dinner with her in Berlin in 1929: "After the meal, thirty letters by Van Gogh in an excessively ornate, horrible binding, were handed round with the cigarettes and coffee. Poor Van Gogh!"[5] Hanging in Goldschmidt-Rothschild's grand reception room was Van Gogh's painting *L'Arlésienne*,[6] which she had purchased when she was just twenty-two. A decade later, in 1940, with Germany's invasion of France, Goldschmidt-Rothschild fled Europe, with the letters and canvases by Van Gogh in tow, and reached New York five months after her departure from Paris. Following her death in 1973, the Van Gogh letters were passed on to a grandson, and in 2001 the New York collector and dealer Eugene Thaw purchased nineteen letters and shortly afterward donated them to the Morgan Library and Museum in New York.[7] Thaw had also owned one of Van Gogh's important Arles paintings, *Flowering Garden*.[8]

In 2023, I had the opportunity to study the original letters at the Morgan Library. Although excellent facsimiles and transcriptions are available, reading the originals gave me a sense of immediacy. I became more aware of how much Van Gogh's expressive handwriting changes even within the same letter, sometimes apparently reflecting the emotion behind what he was writing.

*

* *

Bernard and Van Gogh were in face-to-face contact for a relatively short period. They likely first met in Paris at the studio of Fernand Cormon, where they were both studying. Bernard had already been there for two years when Van Gogh joined soon after his arrival from Antwerp in February 1886. Bernard was dismissed the following month. (The story goes that Cormon asked his pupil why he had painted something the way he had. Bernard responded that it was because "he saw it that way." Cormon retorted that he had better go and see things that way somewhere else.[9]) Bernard then left for what turned out to be a six-month walking tour of Brittany, returning in October 1886. While in Brittany, Bernard met Paul Gauguin in the artists' colony of Pont-Aven, an encounter which would soon play a crucial role in the creative development of both artists.

On Bernard's return to Paris he met Van Gogh again at the shop of the elderly paint seller Julien Tanguy, a regular meeting place for the impressionists and their younger followers. According to Bernard, Van Gogh "almost lived there."[10] Bernard and Van Gogh bought their paint and canvas there, and both also completed portraits of Tanguy.[11] Bernard was eighteen and Van Gogh was thirty-three, yet despite their difference in age, the two men found that they had much in common. Both were frustrated with traditional art practices and were searching for more radical styles. Their different stages in life meant that Van Gogh sometimes played the part of the older and more experienced adviser, as is evident in his letters.

The two artists quickly developed a close friendship. They exchanged paintings and often painted together in Bernard's studio in Asnières, on the outskirts of Paris. Van Gogh eventually owned five works by Bernard.[12] On Van Gogh's initiative, they both collected Japanese prints, images which influenced their own work and which they also discussed later in their correspondence. In Paris they had endless conversations about art and enjoyed Montmartre's boisterous social life, surrounded by other avant-garde artists including Gauguin, Henri de Toulouse-Lautrec, Charles Angrand, and Lucien Pissarro.

In November 1887, Van Gogh organized an exhibition of works by his colleagues at the Restaurant du Chalet, on the edge of Montmartre. Its dining room was hung with hundreds of pictures, including many by Van Gogh. It was probably at this display that Van Gogh first met Gauguin, who had just returned from a seven-month trip to Panama and Martinique. Bernard later recalled, "Unfortunately, this socialist exhibition of our inflammatory canvases came to a rather sorry end. There was a violent altercation between the owner and Vincent, which made Vincent decide to take a handbarrow without delay and move the whole exhibition to his studio."[13]

Only one letter from Van Gogh to Bernard from their Paris period survives.[14] Dating from December 1887, it was written to make up following a row. Van Gogh had apparently stormed off, after arguing that Bernard should not have opposed Paul Signac exhibiting in the Restaurant du Chalet show. Bernard, now a highly cre-

ative artist in his own right, had already started to question Signac's reliance on neo-impressionist dots. (After working in a neo-impressionist style some months earlier, Bernard, along with Louis Anquetin, had developed cloisonnism, a technique that relies on flat plains of color, separated by distinct outlines.) Van Gogh and Bernard continued to meet frequently until the Dutchman left for Arles in February 1888. Van Gogh's parting words to Bernard were an invitation to join him: "The future studio must be established in the Midi [South]."[15]

*
* *

The bulk of Van Gogh's letters to Bernard come from his time in Arles. As Bernard explains in his 1911 preface (pp. 60–113), this correspondence represented "the tie that united us." Van Gogh enjoyed writing at length, which, Bernard writes, "allowed us to be friends, to get to know each other, during this separation."[16]

Van Gogh first wrote to Bernard from Arles on March 18, 1888, three weeks after his arrival, saying that "this part of the world seems to me as beautiful as Japan for the clearness of the atmosphere and the gay color effects." He encouraged Bernard to follow, noting that "there'd be a real advantage in emigrating to the south for many artists in love with sunshine and color."[17] The following month, Van Gogh stressed the importance of writing: "There are so many people, especially among our pals,

who imagine that words are nothing." Yet alongside the art of line and color, there is "the art of words."[18]

In May 1888, Van Gogh had important news for his friend: "I've rented a house painted yellow outside, whitewashed inside, in the full sun."[19] In the yellow house there was space for a fellow artist from Paris to stay. Van Gogh was lonely and longed for company; working together would be stimulating; and sharing accommodation would be cheaper. Two months later Van Gogh said he hoped that their mutual friend Gauguin would come to Arles. Bernard, who had just arrived in Brittany, where Gauguin was then based, was again invited to the south.

Van Gogh's early artistic efforts in Arles were focused particularly on Provençal landscapes. Wanting to keep Bernard informed about his progress, he wrote on April 12: "I'm busy with the fruit trees in blossom: pink peach trees, yellow-white pear trees. I follow no system of brushwork at all; I hit the canvas with irregular strokes."[20] By June, he was painting "in the wheatfields at midday, in the full heat of the sun, without any shade whatever, and there you are, I revel in it like a cicada."[21] That month he worked intensively and then wrote letters in the evenings, unwinding after his labors with paint: "Writing is restful and diverting.... My eyes are tired, even if my brain isn't."[22]

The two men appear to have also reveled in risqué repartee. In late June, Bernard sent ten drawings, including a lighthearted impression of a brothel inte-

rior, inscribed *à mon ami Vincent ce croquis bête* ("to my friend Vincent this silly sketch"). A man who looks like Van Gogh is sitting with a bottle and staring at an extravagantly clad woman, with the stern madame just behind them.[23] In October, Bernard sent eleven watercolors and drawings in a folder inscribed *au bordel* ("at the brothel").[24] Bernard also shared his poem titled "La Prostitution" in an earlier letter.[25] Van Gogh was disappointed not to receive more serious drawings from Bernard after sending fifteen sheets reproducing some of his best Arles paintings.[26] Mostly drawn with a reed pen, these are very fine works, giving an excellent impression of his compositions (see pp. 123, 124).

In an August 1888 letter, Van Gogh wrote, "Oh, the beautiful sun down here in high summer; it beats down on your head and I have no doubt at all that it drives you crazy. Now being that way already, all I do is enjoy it." Then came his ambitious plan: "I'm thinking of decorating my studio with half a dozen paintings of *Sunflowers*."[27] Bernard had earlier that year created a *décoration* for his studio in Asnières that included flowers, and this could well have helped inspire Van Gogh's famed sunflower still lifes.[28]

In the summer of 1888, Gauguin and Bernard were both working in Pont-Aven, Brittany. In September, the trio exchanged paintings at Van Gogh's instigation. Bernard sent Van Gogh a self-portrait, which included a small sketched portrait of Gauguin apparently pinned to the wall behind. Gauguin made a similar work, a

self-portrait with a profile outline of Bernard at the back. Van Gogh sent each of them a work from Arles.[29]

Gauguin arrived in Arles on October 23, 1888. Van Gogh reported to Bernard a week later: "Gauguin interests me greatly as a man.... We're in the presence of an unspoiled creature with the instincts of a wild beast. With Gauguin, blood and sex have the edge over ambition. But enough of that, you've seen him close at hand longer than I have, just wanted to tell you first impressions in a few words."[30] Gauguin had brought with him a key cloisonnist painting by Bernard that he had been given in Pont-Aven, *Breton Women in the Meadow.*[31] Van Gogh was so enthusiastic about it that he made a large watercolor copy. He congratulated Bernard, saying that the composition was "so beautiful, the color so naively distinguished."[32]

Gauguin's stay would soon end in tragedy: on December 23, 1888, Van Gogh severely mutilated his ear. The Dutchman was hospitalized and Gauguin left on Christmas Day, taking the train back to Paris. The dream of a "studio in the South" had been shattered.

Although Van Gogh's physical wound healed, his mental state remained fragile. He suffered a series of breakdowns and was in and out of hospital for several months, although for part of the time he was quite capable of working and produced some fine paintings. In May 1889, Van Gogh retreated to the asylum of Saint-Paul-de-Mausole, on the outskirts of Saint-Rémy-de-Provence.

In light of these events, Bernard wanted to write a tribute to his friend's art. In the summer of 1889, he drafted

a short article for the weekly publication *Le Moderniste illustré*.[33] Bernard recorded that Van Gogh had studied at Cormon's and that he had "the reputation of a raging revolutionary." Bernard recalled: "He would make three studies each session, getting bogged down in impastos, constantly starting all over again on new canvases, painting the model from all sides, while the pathetic students who laughed at him behind his back took eight days to make an idiotic copy of a foot." Bernard did not mention Van Gogh's mental state, describing him as leading "a very simple" and determined life: "Rain, wind, dew, snow, he braves everything. He gets down to work at any hour of the day or night to paint either a starry sky or a midday sun." However, the article was never published, as the short-lived journal closed down in September.

*

* *

It was almost a year before the correspondence resumed. Van Gogh eventually wrote to Bernard on October 8, 1889, after hearing from Theo that his friend had returned to Paris from his summer in Brittany, where he had been working with Gauguin. Bernard had planned to visit Theo three days earlier, partly to see Van Gogh's recent paintings. Bernard may also have hoped that Theo might buy some of his paintings to sell in his gallery, although this did not happen.[34]

Van Gogh commented: "I hardly have a head for writing, but I feel a great emptiness in no longer being at all up to date with what Gauguin, you, and others are doing."[35] Discussing his work in Provence, Van Gogh wrote of the challenges of giving "strength and brilliance to the sun and the blue sky, and to the scorched and often so melancholy fields their delicate scent of thyme." Upon receiving Bernard's response, which included photographs of his recent work, Van Gogh wrote again: "If I haven't written for a long time, it's because, having to struggle against my illness and to calm my head, I hardly felt like having discussions." But now "my mind is somewhat stronger, previously I was afraid of overheating it before I was cured."[36] Turning to work, Van Gogh wrote about the problems of creating "abstractions" in art, stressing the importance of "immersing oneself in reality" and painting in front of the motif. He criticized one of his own paintings, *Starry Night*:[37] "I'm allowing myself to do stars too big, etc., new setback, and I've enough of that." He then was highly critical of Bernard's religious paintings depicted in the photographs. He dismissed *Christ in the Garden of Olives* as "a nightmare" and *Christ Carrying His Cross* as "atrocious."[38] They were not successes and seem to have been a step backward. It is unclear whether Bernard responded—Van Gogh's outspoken comments seem to have brought their correspondence to an end.

*

 * *

In May 1890, Van Gogh left the asylum, moving to the village of Auvers-sur-Oise. He spent three days in Paris en route, with Theo and his wife, Jo, but Bernard was in Lille, so their paths did not cross. Tragedy struck soon thereafter: On July 27, 1890, Van Gogh shot himself. Two days later he died from his wound, with Theo at his bedside.

Bernard attended the funeral on July 30, traveling from Paris. The following day Bernard reported back to the art critic Albert Aurier on this agonizing occasion: "The coffin was already closed, I arrived too late to see him.... The innkeeper told us all the details."[39] Bernard explained that Van Gogh's "suicide was absolutely calculated," undertaken with "total lucidity."

Bernard described the scene at the inn: a white drape over the coffin, with "masses of flowers, the sunflowers that he so loved, yellow dahlias, yellow flowers everywhere." Yellow represented a "symbol of the light that he dreamed of finding in hearts as in artworks." Bernard helped fill the room with Van Gogh's latest paintings, many of which were hardly dry. The mourners then set off from the inn: "We climbed the hill of Auvers talking about him, about the bold thrust he gave to art, the great projects that he was always planning, about the good that he did every one of us." The ceremony at the cemetery was brief.[40] A month later Bernard returned to Auvers to pay homage at his friend's graveside.[41]

<center>*</center>
<center>* *</center>

Bernard was by far the most active friend in promoting Van Gogh's work after his death. Theo and Bernard immediately tried to arrange an exhibition at the gallery of Paul Durand-Ruel, one of the few dealers who handled impressionist works, but this did not proceed. Instead, in late September 1890, Bernard helped hang "a few hundred" pictures in Theo's apartment for a private show.[42] It was one of the largest Van Gogh displays ever held.

Another tragedy was to follow: on January 25, 1891, after suffering from syphilis, Theo died in Utrecht. Jo remained in the Netherlands after her husband's death, and Bernard helped arrange the transport of Van Gogh's paintings to her from Paris. Totaling 258 works, they were packed in twenty-seven crates. Jo's brother Andries Bonger, whom Bernard had met at Van Gogh's funeral, helped with the arrangements, and Andries ended up becoming a major collector of Bernard's work.

Following Theo's death, Bernard regarded it as even more important to promote Van Gogh's legacy. He wrote the first published biographical account of his friend, which was featured in July 1891 in a four-page pamphlet in *Les Hommes d'aujourd'hui* (pp. 30–35). For the cover he produced a line drawing of a Van Gogh self-portrait that he owned (p. 5).[43]

A few weeks later, on September 1, 1891, Bernard published a short note on Van Gogh in the French bi-

monthly journal *La Plume*, describing his friend's physical appearance: "Reddish hair (a goatee, untrimmed moustache, shaven on top), an eagle eye and a mouth incisively set as if to speak; of medium size, stocky but not too much, lively gesture, jerky walk—such was Van Gogh, with his pipe, a canvas or engraving or a portfolio."

In April 1892, Bernard succeeded in organizing a modest show, Van Gogh's first proper solo exhibition in a public venue, at the avant-garde Parisian gallery of Le Barc de Boutteville. Bernard produced a woodcut print with a listing of sixteen works, which included a version of the *Sunflowers*. His extracts of Van Gogh's letters in the *Mercure de France* soon followed.

Later, while in Egypt, Bernard printed an article on his friend in the Cairo-based French-language journal *L'Arte*, on February 9, 1901.[44] As Bernard explained: "Vincent the man is no less present in his writings than in his painted works. He traces his own history here, more profoundly than any of us can tell it."

In August 1939, Bernard returned to Pont-Aven, sixty years after his stay there with Gauguin.[45] While Bernard was there, a plaque celebrating their encounter was unveiled at the Pension Gloanec, where they had lived and worked. War broke out less than a month later. Bernard died in his studio in Paris on April 16, 1941, aged seventy-two. The modest number of obituaries focused primarily on his links with Van Gogh and Gauguin, largely due to his extensive writings.

Although Bernard produced truly revolutionary paintings during the period he knew Van Gogh, by the 1890s he had reverted to a traditional, classical style. For half a century, the work he made was conventional, despite his eagerness to write on avant-garde artists. By 1941, Van Gogh, who managed to sell only one work during his lifetime, was considered one of the greatest artists of modern times.

Notes

Vincent van Gogh's letters, referenced here by date and number, are from *Vincent van Gogh: The Letters, the Complete Illustrated and Annotated Edition*, edited by Leo Jansen, Hans Luijten, and Nienke Bakker, published by the Van Gogh Museum, Amsterdam, and Huygens ING, Amsterdam, in 2009. They were consulted online at https://vangoghletters.org, where readers can find Van Gogh's full correspondence, along with the definitive accompanying explanatory notes. Van Gogh's works are cited by the F numbers in *The Works of Vincent van Gogh: His Paintings and Drawings*, ed. J. B. de La Faille (Amsterdam: Reynal, 1970). Their current locations are also noted.

1 Vincent van Gogh, to Émile Bernard, April 19, 1888, letter 599.

2 Émile Bernard, Preface to *Letters from Vincent van Gogh to Émile Bernard*, this volume, p. 75.

3 Short extracts were published in English in *Van Gogh in Perspective*, ed. Bogomila Welsh-Ovcharov (Englewood Cliffs, New Jersey: Prentice-Hall, 1974), pp. 37–41; *Van Gogh: A Retrospective*, ed. Susan Stein (New York: Park Lane, 1986), pp. 90–92, 237–239, 282–285.

4 The *Mercure de France* had published an important article on Van Gogh by Albert Aurier, in January 1890.

5 Charles Kessler, *The Diaries of a Cosmopolitan: Count Harry Kessler, 1918–1937* (New York: Vintage, 1971), p. 374. There were twenty or twenty-one letters with Goldschmidt-Rothschild at that point.

6 F489, Musée d'Orsay, Paris.

7 See *Vincent van Gogh: Painted with Words, the Letters to Émile Bernard*, ed. Leo Jansen, Hans Luijten, and Nienke Bakker (New York: Rizzoli, 2007).

8 F430, private collection.

9 A. S. Hartrick, *A Painter's Pilgrimage through Fifty Years* (Cambridge, England: Cambridge University Press, 1939), p. 42.

10 *Mercure de France*, December 16, 1908. This article comprises Bernard's memories of Tanguy. My translation.

11 Van Gogh's portraits are F263, Ny Carlsberg Glyptotek, Copenhagen; F363, Musée Rodin, Paris; and F364, private collection. Bernard's are in Jean-Jacques Luthi and Armand Israël, *Émile Bernard: sa vie, son oeuvre; catalogue raisonné* (Paris: Editions des Catalogues raisonnés, 2014), nos. 92, Kunstmuseum, Basel, and 93, private collection. All probably date from 1887.

12 Luthi and Israël, nos. 36, 47, 94, 107, and 144. Bernard eventually had fifteen paintings by Van Gogh, but most may have been acquired shortly after Van Gogh's death. See Jansen, Luijten, and Bakker, *Painted with Words*, pp. 366–367; and Neil McWilliam, *Émile Bernard: Au-delà de Pont-Aven* (Paris: Institut national d'histoire de l'art, 2012), pp. 67–68.

13 Bernard, note to the first letter, from 1887, in *Lettres de Vincent van Gogh à Émile Bernard* (Paris: Ambroise Vollard, 1911), p. 75. My translation.

14 Van Gogh, to Bernard, c. December 1887, letter 575.

15 Bernard, Preface to *Letters from Vincent van Gogh to Émile Bernard*, this volume, p. 75.

16 Bernard, Preface to *Letters from Vincent van Gogh to Émile Bernard*, this volume, p. 75.

17 Van Gogh, to Bernard, March 18, 1888, letter 587.

18 Van Gogh, to Bernard, April 19, 1888, letter 599.

19 Van Gogh, to Bernard, c. May 22, 1888, letter 612.

20 Van Gogh, to Bernard, c. April 12, 1888, letter 596, this volume, p. 115.

21 Van Gogh, to Bernard, c. June 19, 1888, letter 628.

22 Van Gogh, to Bernard, June 26, 1888, letter 632.

23 Van Gogh, to Theodore van Gogh, June 23, 1888, letter 630n4. *Brothel Scene*, Van Gogh Museum, Amsterdam.

24 Van Gogh, to Theodore van Gogh, October 4–5, 1888, letter 697n10.

25 Van Gogh, to Bernard, c. May 22, 1888, letter 612n5.

26 Van Gogh, to Bernard, July 15, 1888, letter 641, this volume, pp. 117–119, and July 17–20, 1888, letter 643, this volume, pp. 120–122.

27 Van Gogh, to Bernard, c. August 21, 1888, letter 665.

28 Van Gogh, to Bernard, c. April 12, 1888, letter 596, this volume, p. 115, and October 3, 1888, letter 696, this volume, p. 132.

29 The works were: Gauguin (Van Gogh Museum), Bernard (Luthi and Israël, no. 144, Van Gogh Museum), and Van Gogh (F476, Fogg Art Museum, Cambridge, Massachusetts, and F449, Museum Folkwang, Essen).

30 Van Gogh, to Bernard, November 1–2, 1888, letter 716.

31 Luthi and Israël, *Émile Bernard catalogue raisonné*, no. 115, private collection. Van Gogh's copy is F1422, Civica Galleria d'Arte Moderna, Milan.

32 Van Gogh, to Bernard, c. November 26, 1888, letter 822.

33 MaryAnne Stevens, *Émile Bernard, 1868–1941: A Pioneer of Modern Art* (Zwolle, Netherlands: Waanders, 1990), pp. 381–383; Jansen, Luijten, and Bakker, *Painted with Words*, pp. 360-365; and McWilliam, *Au-delà de Pont-Aven*, p. 100. The original manuscript is now held at the Morgan Library and Museum.

34 Theodore van Gogh, to Vincent van Gogh, October 4, 1889, letter 807.

35 Vincent van Gogh, to Bernard, c. October 8, 1889, letter 809.

36 Van Gogh, to Bernard, c. November 26, 1889, letter 822.

37 F612, The Museum of Modern Art, New York.

38 Luthi and Israël, *Émile Bernard catalogue raisonné*, no. 214 and possibly no. 102. Twentieth-century photographs of both works survive.

39 Bernard, to Albert Aurier, July 31, 1890, in McWilliam, *Au-delà de Pont-*

Aven, pp. 117–119. Translation from Martin Bailey, *Van Gogh's Finale: Auvers and the Artist's Rise to Fame* (London: Francis Lincoln, 2021), pp. 131–133, 143.

40 An 1893 Bernard painting of a funeral procession is said to depict Van Gogh's, although this is not certain (Luthi and Israël, *Émile Bernard catalogue raisonné*, no. 335, private collection).

41 Theodore van Gogh, to Dr. Paul Gachet, September 12, 1890. Van Gogh Museum archive, b2015.

42 As reported in *Algemeen Handelsblad*, December 31, 1890.

43 F526, Detroit Institute of Arts.

44 This article may have been first published in Paris in 1894 in *Le Coeur*.

45 Just before his return, an English edition of the letters to Bernard, edited by Douglas Lord and titled *Vincent van Gogh: Letters to Émile Bernard*, was published in 1938 by Cresset Press in London. Lord had also wanted to include an English translation of Bernard's 1911 preface, but Bernard refused permission.

Cover of *Lettres de Vincent van Gogh à Émile Bernard* (Paris: Ambroise Vollard, 1911)

Vincent van Gogh

Written in Paris; published in *Les Hommes d'aujourd'hui*, July 1891

He was my beloved friend, and I wish to speak of him. But I am seized with apprehension. What will the rare curious individual who reads these notes think of them? Generally—and understandably—we tend to mistrust the tributes heaped upon the dead by friends, or even by family. And yet these commentaries seem so much more valuable than most others. Who knows us better than those we love, especially in art, where all friendships are based on similar aspirations and harmonious points of view?

I met Vincent van Gogh for the first time in Cormon's studio. Plenty of people were mocking him behind his back then, as someone "who didn't deign to see anything." I next encountered him at Tanguy's shop, that chapel of rest whose kindly priest embraced us so warmly, and with uncompromising integrity. When he emerged from the back room, with his broad high brow, he was so striking that I was almost afraid of him. We became fast friends, opening up to each other as we unwrapped boxes shipped from Holland and portfolios of drawings. What stunning sketches! Mournful processions under gray skies, a common grave; views of massive angular fortifications; scenes of the Moulin de la Galette beneath gray northern skies; then the meager gardens, the roads stretching away into the twilight, and the peasant faces with African eyes and mouths. On the table, among Japanese prints, were balls of yarn whose intertwined strands played unforeseen symphonies.

Amid this chaos I was struck by a picture of a paupers' repast in a sinister hovel, with a lamp casting a dull glare.

He titled it *The Potato Eaters*—it had a singular ugliness and a disturbing sense of real life.

He closed the drawers, and our talk turned to literature. Huysmans utterly captivated him. He praised *En ménage* most extravagantly, and then *À rebours* later in our conversation. He also enjoyed Zola. It was while reading him that Vincent thought of painting the humble sheds of Montmartre, where householders come to tend a little plot of sandy soil at the dawn of every day.

In the realm of painting, he admired Monticelli and Delacroix most of all. He spoke of Millet with reverence and expressed disdain for the so-called modern classicists. But no matter how absolutist his views, he had an open mind toward anyone whose first love was art, and he studied every work with equal attention. Later, when we had become close friends, he initiated me into all his projects—and how many of them there were! What discouraged him was not his own lack of admirers, but rather seeing Pissarro, Guillaumin, and Gauguin in straits that impeded their productivity and paralyzed their efforts. That led him to enlist his brother Theodore (who was an expert at Boussod et Valadon) in a campaign to get these painters accepted in the official salons that exhibited only utter incompetents. And he was quite successful in this effort with his devoted brother's support.

After experimenting with an exhibition at a popular restaurant on avenue de Clichy, he was drawn to the Midi [South] (where his teacher Monticelli mostly lived), and he set off for Arles.

There is a substantial trove of letters written from Arles. One day we hope to offer a sampling of their most interesting passages as well as his first truly distinctive canvases.

He had painted Asnières in an indecisive pointillist style. He then used complementary bands of color in various still lifes, including the famous *Les livres jaunes* [*Piles of French Novels*] that he exhibited at the Salon des Indépendants in 1888. But it was in Arles that he gained the confidence to use a very pictorial personal technique: for example, in the *Rhône*, the *Sower*, *La Berceuse* [*Woman Rocking a Cradle*], the *Olive Trees*, and the *Vines*. He loved those olive trees, and he was preoccupied by their intense symbolism. Because of Christ in Gethsemane I am painting the olives, he wrote to me. Each of those works has its own story, like that of *La Berceuse*: "Fishermen at sea by night see a supernatural woman on the prow of their boat. This apparition frightens them not at all, because she is the cradle rocker, the woman who gently tugs the ropes attached to the cradle of a restless child. It is she who returns on the waves to sing the beloved canticles of childhood, the songs that soothe and console simple men throughout their hard lives."

(But I do not wish to divulge anything new or interesting here that will be revealed in the publication of these letters.)

He painted *La Berceuse* with the intention of giving it to an inn either in Marseille or Saintes-Maries, where sailors congregate to drink. He painted two enormous

suns as pendants, seeing the supreme splendor of love in their bright yellow hues.

The spirit of Rembrandt still haunted him, however. Vincent's thoughts seem to have been bent on his native land. From memory he painted several scenes that were much admired there. In the works we found in Auvers after the burial, there were various studies resembling old Delft tiles, antique enamels, thatched hovels, and rows of trees that evoked the windy land where he learned his first words.

Any individual work may seem incomplete on its own, but Vincent made his intentions clear in the sheer quantity of his paintings. His inner turbulence created a sense of continuity and unity over the long run. Taken together, his works show him to have been very balanced, very logical, very aware. None of the later canvases gave any suggestion of madness. What they do reveal in their present form is genius! I know all too well how easily we feel ashamed of our dreams and our abstractions. We exceed the goals of art, becoming monstrous egotists. We think of ourselves alone and forget the roles of buffoon and clown that are assigned to us with the label of "artist." And then how they mock us when, disgusted by harsh realities, we set sail for elsewhere, adamantly refusing to entertain the mobs. Nevertheless, Van Gogh was a realistic and subjective man who painted everything from manure piles to daybreaks, enchanted by "lichens of sunlight and mucus of the sky."

His brush painted all these things, and his paint tubes spit them out with the sublime wingspan of a drunken mystic or an artist in heat.

There is inspiration in the biblical harvests depicted at twilight; the sheaves, laden with seeds, are heaped into vast mounds; their blades wave like golden banners. We feel sadness before those dark cypresses and the magnetic spears that fix the stars with their points; we marvel at nights like pyrotechnic symphonies sparkling in the shadows of an ultramarine sky. Then we dream beneath groves of flowers that glitter like fallen stars. On a peaceful bank, we see a river that flows without a ripple toward mournful foothills, passing cottages veiled by willows. Having experienced this wave of emotion, we study the eyes of the sitters in his portraits. We see the acknowledgment of lives that are sad or shameful, benign or sinister. Then we will be on the path to understanding Vincent and admiring his work.

As I study the portrait that he gave me and which I've done my best to sketch for this publication—when I think of all the other things he could have done had he lived—I envision the burial on that hillside in Auvers, bathed in tropical sunlight amid the rustling of ripened wheat. And I see a lonely tomb: from it, Vincent calls to the beloved brother who was so devoted to him and whose name will always remain indissolubly linked to his.

Vincent van Gogh was thirty-seven when he died.

Preface to Letters from Vincent van Gogh

Written in Pont-Aven, France; published in the *Mercure de France*, April 1893

I

This mysterious artist killed himself in Auvers-sur-Oise on July 29, 1890. His brother was Theodore van Gogh, an expert at the Boussod et Valadon gallery on boulevard Montmartre. Through their correspondence, we will see the influence that Vincent had on public opinion by introducing impressionism into the gallery of one of the best-known and most influential companies. But I would emphasize first and foremost that these brothers shared a single ideal, that each of them nourished and lived in the life and thoughts of the other. When the painter died, his brother followed him into the tomb just a few months later, felled by terrible and tragic grief.

II

To understand Van Gogh and the path followed by so many artists, you must know the following:

1. That it is not necessary to study the fine arts in a school;

2. That Beauty is not an imitation of a preestablished type. Instead, it is the emanation of all that is sublime, encompassed in every new truth that an artist encounters.

Van Gogh imitated neither the Greeks nor the Romans. He knew enough to admire them—those "calm perfections," he called them—but he considered it futile to subject his artistic temperament to forms of beauty that did not emanate from within himself; they ceased to be beautiful the day that they became mere imitations.

For the essential nature of Beauty is the poignant authenticity that it encompasses, the profound new truth that it contains. This question, which is raised far too often, is the source of many errors and much pointless debate. Eugène Delacroix inquired (in his diaries): "Is there a special technique, some recipe for achieving what is referred to as the *beau idéal*? Is the sense of Beauty the impression that a painting by Velázquez makes upon us, an engraving by Rembrandt, or a scene by Shakespeare? Or is Beauty revealed to us in the straight noses and accurately rendered draperies of Girodet, Gérard, and other pupils of David? Silenus is beautiful, a faun is beautiful. The head of Socrates in classical art is full of character, with a flat nose, a thick-lipped mouth, and little eyes." The master concluded, "When a painter tries too hard for expression in a conventional style, he will be under stress. He will lose his distinctive touch. But when he fully embraces originality, whether it goes by the name of Raphael, Michelangelo, Rubens, or Rembrandt, he will always be secure in his greatness and artistic power."

Vincent believed the same thing, as does every great artist instinctively. Furthermore, there is no absolute Beauty except where Form ceases to exist, and since this beauty is incompatible with the plastic arts, it is pointless to discuss the matter. Art is the vision of the sublime, so what would we ask of it save the accomplishment of this mission? Where the sublime is absent, art ceases to be.

Vincent did indeed see the sublime.

Let us establish what constitutes sublimity in art.

In real life, it is the mother who dies to save her son, it is Eugénie Grandet's consuming love, it is the friendship between Pons and Schmucke, it is Balthazar Claes's passion for the Absolute. In sum, there is heroism in life. Art comprises all of that, as well as much more. Sublimity in art begins beyond the actual object, in the revelation given to us by the object. Thus the pictorial representation of the scenes described above has no ability, materially speaking, to convey in its objectivity the faintest idea of what we mean when we speak of sublimity. Consider an Egyptian temple or a Gothic cathedral. Everything about them is sublime—that is not subject to debate—we feel it. Everything about them elevates us, everything captivates us, everything becomes a pedestal to raise us above the world with its woes, cares, troubles, and tyrannically narrow-minded opinions. A vast breath of fresh air overwhelms us; the columns have all the majesty of long-lost forests. Dreams reveal how the ogival arches, the vast vaults, and the deep crypts have the grace of flowering branches in April or hold the mysteries within the grottoes of the sea. Nature in its essence resides here. It is nothing material. It is sublimity; it is divinity; it is immensity; it is God; it is the all-powerful and its vast verities. This is sublimity in art: showing one of the truths hidden behind mystery, vastness, and grace. Sublimity entails the union of sound, color, and fragrance to form Harmony. It is the gift of equivalences, affinities,

interpenetrations—in short, the gift of vision. Vincent van Gogh possessed this gift.

I am not speaking here of the canvases that will later attest to this gift. We are concerned here with the publication of letters, so I will speak solely of them. Consider the entire collection of letters that we are publishing now and note their central concerns. There is as much theology as fellowship, as much on criticism as on painting. Compare the letters to each other, and observe how they form links of the same chain, a harmony that is born of analogy. The very greatest geniuses are named repeatedly. You'll find the names of saints, apostles, scholars, and painters, even of God Himself—Jesus, Rembrandt, Giotto, Delacroix, etc. Each of these names evokes a world of corresponding ideas that complement one another and join together to lead us toward the sublime. The very existence of this cult of genius proves that Van Gogh had the supreme vision.

I would say that without a vision of the sublime, there is no artist—that is an obvious fact. If art contains none of these great qualities that make a man worthy of God and himself, if the language is merely trivial and flat, whence comes what is most noble in human intelligence? Something ceaselessly demands that we try to prove—to people's childish brains—the verities that the most solid reasoning cannot print or make understood. That is what art makes us feel, and feeling is perhaps something beyond understanding.

Causing something to be understood is to establish,

through a logical sequence of reasoning, that an event has become possible and has occurred. But in the great question of divinity, for example, it is as impossible to prove God as to deny him. Here is where art participates in the sublime, for it alone can cause God to be sensed when neither words nor reasoned arguments can make us understand. Study the works of the Italian primitives to observe this effect. No one expresses better the God that these artists loved. No material manifestation proves it better than Augustine's paeons of love, or the transports of Saint Catherine of Genoa and Saint Thérèse pouring their lives out in prayer. And look even farther back to the images of the Greek gods, Egyptian stelae, and primitive idols. Do you not experience a succession of sensations—sympathy, dread, horror, wonder—engendering feelings of devotion, fear, and attachment? Art expresses divinity, and only art has the power to do so. It has therefore become the divine language. This explains why other approaches are futile. Art is not the depiction of that which is. It is the eternal truth hidden within the shifting forms of objects and of beings, of worlds and of gods.

<center>III</center>

Here are the notes I received from Monsieur Bonger, one of Vincent's most sincere admirers and close friends. He was among the first to recognize the painter's genius despite the widespread misunderstanding of his work.

"Vincent van Gogh was born on March 30, 1853, in Groot-Zundert (Holland). He died at Auvers-sur-Oise

on July 29, 1890. Raised in the country, he loved plants and animals. He was profoundly religious with a simple faith that saw God in everything. He began his career with Goupil in The Hague. He later worked for the same company in London and, in 1872, in Paris. Ill-suited to the demands of commerce, he resigned after a year and returned to Holland for a brief interval. He then went to London, where he earned his living as a schoolmaster. It was a very difficult time for him. He was preoccupied by theological issues and was troubled by the discord between Scripture and Christianity as it is generally practiced. He resolved to pursue theological studies and become a pastor 'in his own way.'[1] He felt a sense of discipleship.

In 1877 he went to Amsterdam, where he enrolled in theology courses but did not complete them. Went to the Borinage (Belgium), to preach to the miners.

He had always drawn and sculpted. It was not until after 1882 that he began to focus exclusively on painting and studied in an atelier in The Hague until 1884.

Brief stay in Drenthe (northern Holland) then at Nuenen, where he lived with his parents; then worked in Antwerp, and moved to Paris in early 1886."

I met him in 1887 in the building where "Papa" Tanguy had his art supply shop at 9, rue Clauzel. I have described elsewhere (*Hommes d'aujourd'hui*) my complete surprise at his striking appearance and my visit to his studio on rue Lepic where his brother Theodore also lived. It was in the 3rd arrondissement in an apartment overlooking

the city. There was a collection of pictures as good as any by the romantics, and numerous Japanese prints, Chinese drawings, and engravings in the style of Millet. There was a huge Dutch cupboard: its drawers were full of balls of yarn that were tangled up together, commingled, and combined in the most improbable ways. This massive piece of furniture also held drawings, paintings, and sketches by Vincent himself. His scenes of Holland impressed me most; they were clean, precise, taut, with a distinctive style. Then there were those astonishing images of farm laborers, with huge noses, thick-lipped mouths, oafish and brutal manners—*The Potato Eaters*, a frightful image, was the culminating work.

Vincent read constantly: Huysmans and Zola impressed him particularly among contemporary writers. A sense of masculine power pervaded one; in the other, it was the caustic bite of a well-aimed lash, mercilessly directed at stereotypes. He always had a horror of the inauthentic.

One odd thing—the most spiritual works held little interest for him. Regarding young poets, even Baudelaire, he said nothing or just gave a little smile. I later understood this attitude better, when he wrote to me that there was no art except in what is healthy. I never believed, as he did, that Baudelaire was unhealthy!

He had an active and questing mind that harbored some bizarre contradictions. He loved Ziem's paintings, for example. His renderings of Venice painted in cream and bleach white that languished for some twenty years

on the facades of rue Laffitte pastry shops appealed to him.[2] Vincent contended that they were the work of a colorist, though he later changed his mind. One day I came across him having a heated conversation with Ziem in front of a building whose balconies were supported by crocodiles. Very much a man of the world, the celebrated painter spoke of Delacroix, describing a toast raised by supporters of the great romantic in the middle of a state dinner. That made it all somewhat comprehensible: I then understood why Vincent admired Ziem—he had known Delacroix and taken his part in a dispute.

Vincent was the finest type of man you'd ever encounter: open, unpretentious, and lively, with a hint of witty malice. He was an excellent friend, an inexorable judge, devoid of egotism and ambition. His letters demonstrate these character traits. They are so simple, and he is as much his genuine self here as in his countless canvases.

We lost the most faithful of friends and truest of artists on that sunny day in July, when he went behind the Château d'Auvers *to strip himself* of his life. However shattering this fact may be, it must be acknowledged. The letter that addresses the question of the "flat life" versus the "round life" may cast a bit of light on what may have led Vincent to that act.

Perhaps he was curious about something else?

IV

It is time to conclude this commentary, which is both too short and too long. I think I have said everything I need

to about the painter. The letters written to his brother Theo will demonstrate his influence on the impressionist movement, as he was instrumental in organizing its success.[3] He was definitively the victor in the hostilities. What did it take, moreover, to overcome? A famed company, and that is what Van Gogh the painter was able to win over. He paid his debt to the only true artists he encountered in his own time, those who decisively paved the way he walked with such distinction.

Readers may say to me, "Your modesty is not in evidence in your publication of the praises that Vincent heaped on your efforts." To them I respond, "There is nothing I value more, and I am happy to have the opportunity to be blamed of this."

Notes

1 Despite his hopes, Vincent did not pursue theological studies. As he had not done prior work in the humanities, the process was too long. He became a pastor in his own fashion, in accordance with his own beliefs.

2 I do not intend to alter this opinion expressed in 1893, which reflects the partisanship of that time. Today I respect the Ziem who painted the magnificent painting *Barques devant Venise* (Musée du Luxembourg) too much not to amend my view.

3 When I speak of the impressionists, I refer to Renoir, Cezanne, Degas, Monet, Sisley, Pissarro. I do not allude to their imitators, already too well-known, given their mediocrity when compared with the five masters who preceded them. Their artistic renaissance is inarguable and impressive: it has given us, after an extended period of more or less abortive imitations, the joy of seeing a new art emerge from five masters that expresses the beauty of various aspects of life and nature.

Preface to Letters from Vincent van Gogh to His Brother Theodore

Written in Florence; published in the *Mercure de France*, August 1893

We present these letters with gratitude for the wisdom and generosity of Madame Van Gogh, Theodore's widow. They prove our contention that "these two brothers shared the same ideas, that each of them drew inspiration from the other, and that—through his brother—we understand Vincent's role in the introduction of impressionism to one of the best-known and most influential galleries." This fact is self-evident, and there is no room for malicious denial. This correspondence enables us to track, step by step, the progress of Vincent's artistic education and his evolving opinions, which flourished through a remarkable dialogue. On one hand, we see the painter gradually perfect himself, extend, broaden, and simplify his art, and develop a sense of confidence. On the other hand, Theo is attentive to everything he receives from his older brother regarding his plans, his health, his struggles with sales, and he offers fresh insights and sound convictions.

There is an intense sense of life and excitement in Vincent's Provence. The southern sunlight illumines vast canvases. Orchards blossom with magical lacework and inventive arabesques swirl across sketch paper. Meanwhile, the tedium of daily routine pervades the dim office of a Parisian commercial gallery. Theo, a proud brother, rejoices at Vincent's abundant output and applauds the seeming fruition of his visionary idea. Their letters have a striking air of openness and spontaneity. They describe the artist's everyday life—his worries, work, and dogged determination. You never hear

sterile pessimism or idleness. If Vincent painted fifteen little flowering orchards, he would have preferred to paint thirty. "Pictures are like rare gemstones," he said. "If they are good, you have to make a lot of them and pay attention to the quality at the same time." There was nothing mercenary in this assertion. He was simply explaining his embarrassing financial situation: he was using vast quantities of colors and canvases, yet needed to paint even more. It was costly, but he could not restrain himself. Today, his work has found so many admirers. We fully understand that Vincent was justified, and we recognize his brother's generosity and love.

A host of difficulties, often financial, may stymie artistic careers. It would take too long to enumerate them here. Many painters were hampered by limited space for displaying their work. Some were not able to paint on a daily basis. Others had to survive by taking jobs that were unpleasant, distasteful, or humiliating. It is said that Claude Monet stopped painting for six months, lacking the money or credit to continue. Now Monet is well known, even famous, and we reflect sadly on how his lack of basic materials has deprived us of his work.

Vincent's accounts of his friends' experiences show how numerous artists suffer from the same challenges today. We should therefore feel genuine admiration for Theo's generosity. He not only agreed "to earn less in order to sell fine gems," but also deprived himself to spare his gifted elder brother from mundane financial concerns. Such dedication is rare: Edgar Poe and his mother

come to mind in connection with such a touching image of self-sacrifice.

Theodore van Gogh was a dealer with Boussod et Valadon on boulevard Montmartre. Despite a vicious campaign launched against him by the official Salon's supervisors, he masterminded the triumph of the impressionists in several smaller exhibitions. This endeavor was a victory from a critical perspective as well as a commercial one. These artists were soon recognized by a broader audience: Renoir, Degas, Monet, Pissarro, and Seurat soon became familiar names.[1] They would, of course, have succeeded through their own efforts given the superiority of their work, but Van Gogh advanced their cause by his intelligent initiatives and carefully reasoned assessments. Vincent was in Arles at the time and was pursuing the idea of opening an exhibition space in the artistic center that would have embraced the concept of a "Renaissance."[2] He proposed an alternative to the established practice of selling only the works of dead painters whose ability was widely recognized, while, in the meantime, talented living artists starved in front of their masterpieces.

We know from their letters how Vincent and Theo intended to manage these exhibitions. Along with painters of the *grand boulevard* (that is, the impressionist masters), they would also include young talent that Vincent referred to as the *petit boulevard*. The exhibitions would have presented a comprehensive representation of contemporary efforts to develop artistic forms free of

academic doctrine. It was a grandiose conception based on establishing an association that would rescue artists from poverty and low productivity.[3] But the plan fell into oblivion together with the generous spirit that had conceived of the mission. Potential participants not only failed to follow up but made no effort to support the ideas presented to them. Did their hesitation arise from compromise or incomprehension? Only they can answer.

Vincent left Arles for Saint-Rémy, where he gradually regained his serenity and lucidity. However, he lapsed into two months of nervous distress when confronted with an array of trying circumstances. He painted his finest canvases during this period: the countryside of Arles, its little mountains, the sunrises and sunsets over fields of green or ripened wheat, and the asylum's park. Unexpectedly, we learned that he was in Auvers-sur-Oise. And then—suddenly—we learned of his death.

He had stayed several months in Auvers. While there, he painted lovely flower pieces, vast expanses of wheatfields, portraits of little girls, Doctor Gachet (almost his masterpiece), and humble cottages worthy of his masters, the greatest Dutch artists. His death was a terrible blow for all of us; we were stricken by its suddenness and tragedy. Theodore collapsed, paralyzed with grief, and died.

You can view Vincent's paintings in the widowed Madame Theodore van Gogh's home in Bussum. They adorn the walls and every room of the spacious resi-

dence. Artists can admire them at leisure, together with the artist's many drawings stacked in bulging crates.

Several articles have been published by Mirbeau, Geffroy, Lesault, and Leclercq. Another who has died, Albert Aurier, wrote an enthusiastic critique of his work in the first issue of the *Mercure de France*.

Young essayists in The Hague and Amsterdam took notice. Two exhibitions were organized, one at the gallery of Monsieur Le Barc de Boutteville in Paris and the other in The Hague under the auspices of Madame Van Gogh. The Salon des Indépendants and the Brussels XX displayed his works posthumously.

That is all it remains for me say about Vincent's letters and the two Van Gogh brothers.

Notes

1 Cezanne remained in obscurity in Aix, forgotten by his friends, who gave little attention to reviving his work.
2 This concept has since been realized, but with mercenary objectives, and in a fashion that is inferior and degrading!
3 It was certainly not founded by dealers and still less by the collectors who should have been involved.

Preface to a Volume of Vincent van Gogh's Correspondence

Written in Cairo in June 1895; Bernard wrote this text for the *Mercure de France*'s volume of Van Gogh's correspondence, which ultimately was not published.

We present the first volume of excerpts of letters by the artist Vincent van Gogh with the kind assistance of Madame Theodore van Gogh, his sister-in-law.

They include new and striking details on the various challenges—including isolation, the company of a colleague, daily life in the world, and nature—that confronted the artist.

Above all, these letters show how very difficult the situation of young artists has become. At the mercy of life's inescapable necessities, they squander their energies in pointless struggles. Mediocrity sits securely on the thrones of reputation, while genuinely talented artists wrestle with the innumerable constraints imposed on them by prejudice, ill will, envy, and corruption.

The reader of this book will be appalled that an effort so heartfelt, so pure, so selfless as Vincent van Gogh's ended in nothing but sorrow and irreparable loss … and this conclusion will seem sadder still if we contemplate the responsibility that we may involuntarily share for this tragedy.

That is the story revealed in this book.

Van Gogh was sustained and nurtured by his close friendship with his brother Theodore. But remember that Vincent was older, and that he and his mother had both more memories and more responsibilities. Consider that he toiled in vain in the "dirty trade of painting," that he could not manage to cover his costs nor repay the monthly stipends sent by his brother.

Driven by an irresistible passion to create, the painter felt that he was always imposing on Theo. Paints were consumed insatiably, canvases worn through. Vincent constantly requested more paint, increasing his borrowings and demanding words of hope and support.

The paintings failed to sell, and expenses piled up relentlessly. Vincent uttered the despairing cry: "I'll return the money or turn up my toes!" This obsession was self-imposed, because Theo made no demands on him and would never have abandoned his brother.

Vincent painted—he painted day and night. When he ran out of colors, he made charcoal drawings. He overtaxed himself, to the point of skipping food to fund the pictures he was driven to paint. Ultimately, this hyperstimulation overwhelmed him, and a catastrophe ensued.

The town of Arles was swept by a strange confabulation of stories. Van Gogh believed he was being persecuted; he suffered a mental collapse during which he severed his ear with a razor. He was locked in a cell. He recovered, however, and hoped that his former life was resuming. But then a new enemy attacked—insanity. Vincent attempted to confront this affliction, but he was terrified of it, feeling it threaten to overwhelm him.

The struggle intensified. He was battling a strange and malignant force, his indebtedness, the demands of his art and his life. Ominous thoughts menaced the edifice of ideas that he had so painstakingly constructed.

But—and this is an admirable thing—Vincent wanted to spare his brother as best he could. He insisted that Theo marry, urging him to convey his fraternal affections to his new wife. He wished his younger brother's household to lack for nothing. These concerns drove Vincent to contemplate joining the Foreign Legion or entering a sanitorium to relieve his brother from concerns over his isolated, insecure existence. He chose to move to the asylum in Saint-Rémy and left Arles with lingering regrets.

This volume concludes with Vincent's last look back at the past. He returned to his "little yellow house," where he had dreamed of lodging other painters, his impoverished and impassioned friends. All had been lost. During his illness, water had leaked into the house and the painted decoration, his pride and joy, was destroyed; anything that remained was ruined and wrecked. Vincent saw his dream shattered and felt everything was over, irrecoverably lost. He thought only of his brother Theo, who had worked together with him on this generous and visionary project. He told himself that goodness at least survived, that goodness would endure.

But he was imagining another ravaged house in that moment. The ruin before his eyes was only its image as he contemplated the entire failed adventure of his abortive artistic project. He could not find words to express his devastation. He did not have the heart to understand how fraternity and superhuman effort had ultimately failed, arriving at this melancholy conclusion, as incomprehensible as life itself.

That is the history told in this first volume. It recounts the fate of a man who felt, lived, suffered, and loved far more deeply than his artistic contemporaries.

It is remarkable—and very rare in our time—to encounter an artist as unpresuming as Van Gogh. He assessed himself modestly: "I'll never amount to much." At a time when so much egotism is on shameless display, it is inspiring to consider this vigorous, committed artist; he was so passionate and gifted, setting an example in his renunciation of popular acclaim. I believe his humility is the most eloquent demonstration of his worthiness.

There would certainly be much to say about the profound inner qualities revealed in each page of these letters, but lack of space prevented us from including them here. There are loving words of affection, family honor, and brotherly solicitude, but excessive familiarity may preclude a full grasp of their power. That is why we have left them private.

The excerpts included here make up only sections relating to three major themes: Vincent's work, life, and thought. We have carefully selected passages from the artist's spontaneous outpourings. Some of these brief exchanges are particularly striking. Consider these observations, for example:

"How beautiful yellow is!"

"The oleander ... it speaks of love."

"The murmur of an olive grove has something very intimate, immensely old about it."

"The paintings fade like flowers . . ."

These phrases occur interspersed within an epistolary conversation. They are mingled with other thoughts, but we discern all the intensity and vivid observation they convey. They are expressions of truly beautiful insights and radiate a sense of youthful joy—in contrast to our own era, with its dreary mood of egotism, sophism, and doubt.

Vincent van Gogh did not doubt, but he suffered from an absence of faith. He confessed that he lacked "a religion" and that this absence was bitter to him. Like all wanderers, he sought guidance in the stars but was not consoled upon return. Like a man who sensed the void behind him, he clung to everything that life offered. He gave himself to art: natures like his are made for love, and love bestows itself upon them.

But hope is not a certainty with art, and maybe hope had deserted him. Perhaps this failure of religion that he complained of engendered the dreadful decision of suicide. If a sense of nothingness is unopposed, it easily swallows its prey. Was the painter seized by despair?

Profound mysteries surround these speculations. They belong to the Omnipotent—to the force that IS. Perhaps Vincent could do no more than cast a light among us. He did so—it only remains for us to perceive its glow.

Not everything disappeared with him. We have his canvases; we will have his letters. We may indeed say that

Vincent the man is no less present in his writings than in his painted works. He traces his own history here, more profoundly than any of us can tell it.

Let us enter this book that is the very heart of the artist, where he lifts the mysterious veil to reveal his inner self.

Preface to *Letters from Vincent van Gogh to Émile Bernard*

Written in Paris; *Lettres de Vincent van Gogh à Émile Bernard* was published by Ambroise Vollard, Paris, in 1911.

On July 29, 1890, Vincent van Gogh was buried in the little cemetery in Auvers-sur-Oise. He had died in obscurity, his works viewed as little better than rubbish and dispersed among the shabby stalls of the flea markets in Clichy and Rochechouart. He has since been transformed into an artist whose work is revered and sought after by arts professionals and collectors alike. Meticulously documented and catalogued, his canvases are now displayed in French and German galleries and hang proudly in the museums of his Dutch homeland. This is a welcome moment for me, Vincent's longtime comrade. I still mourn my friend's premature death and remember him with deep affection. There is now an opportunity to look back on the evolution of his work and reputation before he attained the enthusiastic and unanimous acclaim he enjoys today. Van Gogh has experienced mounting recognition as an artist since his tragic suicide—fame has the singularly ironic proclivity of flourishing amid the tombs. Critics who scornfully dismissed Van Gogh's work while the artist was living are numerous, and art snobs who follow the ebbs and flows of popular taste issue a continual stream of rhapsodic commentary.

If only these critics had had the patience and understanding to study the works that were before their eyes! They would perhaps have taken a more discerning view of what was unique in Van Gogh's oeuvre. Typically, however, they refused to acknowledge anything of merit at the time. Now, swayed by every ephemeral fancy, they indiscriminately embrace everything Van Gogh ever did,

including what the artist himself would have rejected had he been alive to do so.

Contemporary opinion does nothing in moderation. Instead, it lunges from one extreme to another, never achieving a reasonably balanced point of view where the rational principles of harmony prevail.

It is a striking fact—which for a long time distracted collectors and artists—that Van Gogh never sold a canvas for more than a few francs. More often than not, he gave his paintings away to get rid of them and clear out his younger brother Theo's residence, which was hopelessly cluttered.

When Vincent died, this cumbersome legacy was not worth a sou to his brother. Not only could he find no buyer—he was unable to locate any gallery where a few works could be displayed. On September 18, 1890, Theo wrote to me:

> It may seem presumptuous that I approach you to request a favor so boldly, but it is much less for me than for Vincent that I ask it. If he were still alive, you know that we would have moved so that we could more easily display his paintings. We are in the process of moving now, but the number of canvases is overwhelming. I don't have time to sort through the collection so that I can offer a viewing of his work. When I saw how skilled you were at organizing things in Auvers, I immediately had the idea of asking you to help out when it was time to arrange a show. Durand-Ruel ada-

mantly refuses to exhibit the pictures, and all I can do for the moment is hang as many as I can in my house so that I'm able to show them to anyone desiring to see my brother's work. In short, could you lend me a hand in getting out of this difficult spot? As you know, I unfortunately have almost no time during the week, and you're not free on Sundays....

Next week I have an appointment with a foreigner to whom I'm trying to sell some ghastly pictures. So is Saturday possible? Then I can continue to hang some more on Sunday when we've formulated our plan.

I'll try to come for at least part of Saturday so we can settle on the overall layout. Send me word as soon as you get this letter, please, so I'll know what to do. If you agree, we'll have to get started in the morning, around 9:00 or so.

Then I'll go to the shop one time during the morning and once in the afternoon. I hope I won't be interrupting any interesting project you might be working on at the moment.

I hope I can count on you.

A warm handshake. Yours truly,

Theodore van Gogh

I replied to this letter in the affirmative, and I went over to Theo's house on Saturday. The hanging went pretty quickly; I handled it completely on my own.

When it was done, the house resembled a series of museum rooms—I hadn't left a single empty space on

the walls. My objective was to follow Vincent's principles; he had often expressed them to me in his letters. Make a canvas sing by its proximity to another; put a range of yellows beside a range of blues, a range of greens beside reds, etc. The green *La Berceuse* [*Woman Rocking a Cradle*] was on one wall, as luminous between the orange and yellow sunflowers as a village Madonna between two golden candlesticks. When I was finished, I decided to conceal the houses across the way and create a sense of intimacy in this gallery dedicated to a friend's memory. So I covered a window with a stained-glass panel painting that expressed the essence of the *Sower*, the *Shepherd*, and the *Haystacks*, pictures of the countryside that reflected Van Gogh's affection for rural life.

But alas! This memorial tribute only hung for a few months. We had scarcely finished when Theodore, heartsick from his brother's suicide, suffered a mental crisis and collapsed. He was paralyzed by grief, and our desperate efforts to save him were futile. He was taken back to Holland, where he died six months later.

But I did not give up on winning recognition for Vincent. The friends and artists I took to his brother Theo's apartment in Cité Pigalle recognized his gifts as a colorist, and his originality, passion, and ardent commitment to painting. I took photographs of his work and sold them by subscription.

Madame Van Gogh, in her haste to take her husband back to Holland, had left the Paris apartment in disarray. She soon requested that I send her the canvases. I

took responsibility for supervising their packaging and shipment. She had a completely understandable reluctance to return to Paris and France, to a place that had been the scene of a dreadful personal tragedy.

She moved to Bussum, a town near Amsterdam, where she opened a pension. "It's a lovely house," she wrote to me, "and we'll be more comfortably accommodated here—baby, the paintings, and I—than in our apartment in Cité Pigalle, where we were once so happy and I spent the most blissful days of my life. You mustn't fear that the pictures will be relegated to the attic or some dark closet. The entire household will be decorated with them, and I hope you'll come to Holland someday to see that I've taken good care of them." Madame Van Gogh was very desirous of carrying out her husband's wishes. She pursued the idea of mounting an exhibition of Vincent's work and put six thousand francs at my disposal for the purpose. But galleries were few and very expensive. I couldn't do anything for that amount. I resolved to create a show at no cost with Le Barc de Boutteville, who was a good friend and exhibited my works. Although almost everything had been shipped back to Holland and only Tanguy, the painting materials supplier on rue Clauzel, still had a few paintings, I hung a sampling of Vincent's work in Boutteville's gallery. He was perfectly willing to allow me to use one of his rooms for a month for this purpose. I created a catalogue myself with grainy woodblock prints, listing fourteen large-scale works.

What astonished me most about this whole process was Paul Gauguin's attitude. He had been close to the Van Goghs and had benefited from their many acts of kindness. In fact, he owed them his daily livelihood. He had even been introduced to collectors from the Boussod et Valadon gallery (now known as Manzi-Joyant) by Theodore.

Vincent had written to his brother about Gauguin.

"You can tell Gauguin outright for me that in my opinion—on his own behalf and in the interest of the business—his prices are ridiculous."

"I thought of Gauguin and here we are—if Gauguin wants to come here, there's Gauguin's fare, and then there are the two beds or the two mattresses we absolutely have to buy . . . and the two of us will live on the same money as I spend on myself alone."

"I received a letter from Gauguin, who said he'd received a letter from you containing . . . francs, by which he was very touched."

When I informed Gauguin that I planned to show Vincent's work, he—in "gratitude" for all these acts of generosity, which were frequent among the Van Goghs—sent de Haan's painting to Paris. (De Haan was a Dutch fellow who had lived with Gauguin in Le Pouldu and had been his student and assistant.) Gauguin's intention was manifestly to interfere with the exhibition that I was planning in Paris. He wrote to me to say that it was

ill-advised to exhibit the paintings of a madman and that I'd put everyone in jeopardy by an impulsive action: him, myself, and our friends the synthesists. Of course, I had no intention of yielding to these objections, whose intent wounded me to the heart. I completed my project, which had no negative repercussions, by the way. Albert Aurier, whom I'd earlier introduced to Gauguin, didn't write a word about all this in the *Mercure*, espousing the cause of that goblin de Haan. Julien Leclercq was also silent on the matter. I had written to Octave Mirbeau, who responded,

> I wholeheartedly support this exhibition. When shall I send the painting?
> Be assured that I'll do all I can with the press. I'll even write to Magnard today. But there's so much resistance in those circles.
> Most sincerely,
> Octave Mirbeau

Did Octave Mirbeau keep his promises? I never found out. I took the canvases back when the month was over with the sole satisfaction of having performed a duty for a friend.

A little while after that first exhibition, he had several of Vincent's paintings sent to the Salon des Indépendants: *Les livres jaunes* [*Piles of French Novels*], *Les Jardins de la butte Montmartre* [*Gardens of the Butte Montmartre*], and a few little studies. People were starting to talk

about them. Albert Aurier published a much discussed article based on my notes in the first edition of the *Mercure*, and he was constantly importuning his friends and colleagues to get them involved in the campaign. He wrote lively, colorful, lyrical articles where his poet's soul stood in for an aesthetic sense. He was gaining a position of authority at the *Mercure* that sadly was cut short by his untimely death. Aurier was certainly a critic to be watched, despite a certain inclination toward pedantry. His ignorance of painting in general did not give him much authority in this respect. I had won him over as an advocate for Vincent during my first encounter with him in Saint-Briac. He was drawn into my inn by the decorations I had painted on the glass panels of a door. I showed him the frescoes that I'd done on my bedroom walls, and then some letters I'd just received from Van Gogh. He was charmed by their drawings and captivated by their texts.

A romantic to the point of being morbid, Aurier was extravagant in expressing his fascination with Van Gogh, particularly praising his "metallic, gemlike" qualities. In his article on Vincent, Aurier spoke enthusiastically of "skies carved from the dazzle of sapphires and turquoises steeped in infernal sulfurous yellows, hot, destructive, and blinding; skies that evoke streams of molten metal or sometimes flow freely, radiant from torrid solar disks." Finally, he raved over "the streaming of every conceivable form of light, from weighty emanations that seem to emerge from fantastical kilns." And not neglecting

to allude to "the nightmarish flame-like silhouettes of cypresses, squat houses twisting passionately, as well as beings who rejoice in rubies, agates, onyx, emeralds, corundum, chrysoberyls, amethysts, chalcedony, coruscations, etc."

In short, the entire panoply of romanticism and symbolism, seen through wearied eyes. It was typical of the alcohol-fueled impressionism of nocturnal wanderers mesmerized by points of light from gas lamps; in the rain-drenched evenings, the sidewalk is a lake of magical marvels with the perverse seductions of the mermaids' song.

This prose style, dating from 1890, once seemed excessively modern but is now already outdated. These verbal excesses are unfortunately not the expression of a man of taste. A picture is not beautiful because it glints with all the cheap sparkles and precious gems that dazzle the vulgar gaze. We might recall the words of Apelles. When a painter showed him a *Helen* featuring all these artifices, he observed: "Incapable of making it beautiful, you have made it opulent." The coruscating virtuosity that blinded Aurier into raptures is no more than a misguided venture in modern painting which, devoid of spirituality, instead attempts to seduce the eye. The approach is temptingly easy with the palette made available to us by chemists over the last hundred years.

But Aurier had qualities that surpassed these clumsy blunders through the dictionary; he knew how to play the psychoanalyst. I don't particularly admire the way he abused these scientific terms any more than I like his

insistence on demonstrating that Van Gogh was an idealist. Yes, Vincent was expressive even beyond his forms, to the point of deformation and even ugliness. But I must refuse to believe that this ugliness has the ideal as its goal. It is not a question of idealism but rather a simple *idéisme*. Although *idéisme* is anti-traditional and distorting when carried to the extreme, it is perhaps first and foremost naturalistic and scientific.

Exaggerating defects has the effect of opening the discussion to curiosity, asserting claims aloud, shouting above the rooftops, a willingness to see with an entirely fresh perception. But it also deals art, the goal of which is beauty, a brutal blow. Vincent was above all a painter who dreamed of nothing other than fashioning ranges of color and arrangements of lines (for which he should be respected, because that is genuine beauty). He sent a letter to Aurier saying: "You see, it seems to me so difficult to separate impressionism from other things, I cannot see the point of so much sectarian thinking as we have seen these last few years, but I fear its absurdity. And, in closing, I declare that I do not understand that you spoke of Meissonier's infamies. It is perhaps from that excellent fellow Mauve I have inherited a boundless admiration for Meissonier; Mauve was endless in his praise for Troyon and Meissonier—a strange combination. This is to draw your attention to how much people abroad admire, without attaching the slightest importance to what unfortunately so often divides, artists in France. What Mauve often repeated was something like this: 'If

you want to do color, you must also know how to draw a fireside or an interior like Meissonier.'"

That's the response of a painter who is conscious of his métier, heedful of the work itself and its rendering, but who doesn't understand that the poet is asking more from a picture than what the skill of the brushwork can give him. Van Gogh was first and foremost a naturalist, a student in the school of Zola. He loved the sunlight, the open air, the cicadas, the Paradous. And he wasn't wrong. Instead of floundering around in abstractions, he set up his easel wherever he could—in rough terrain, in the street, in the field, and in the midst of a mistral. He was simply a man who was eager to deploy his scales of color like a skillful songster. He astonished the joyful Tyrolians with yellows, oranges, and greens, thinking only of the pleasure experienced in the moment. He was a painter—that is all—and for those who came on the scene around 1890, he was the most expressive. With unique passion, he interjected himself into the picture's very substance by the use of impasto.

Physically handling paint was a delight to him. Just as a miser loves to gloat over his gold, toying with it in secret, he gloried in the solitude of the countryside. Excitedly squeezing his tubes of paint, pressing them out and furiously emptying them onto virgin canvases, he'd stand facing the little mountains near Saint-Rémy, in the villages of La Crau, under the shades outside the asylum where his delirium eventually took him. He was a painter, and a painter he remained. While still young,

he rendered Holland in shades of brown; as a divisionist at a more advanced age, he painted Montmartre and its gardens, and, finally, in furious applications of impasto, he depicted the south of France and Auvers-sur-Oise. Whether he drew or lost himself in expressive—sometimes distorted—brushstrokes, he always remained a painter. And it was this commitment, and the rare harmonies he sometimes achieved in a novel combination of a few tonalities, that makes him worthy of attention and ranks him among the most vital of artistic talents. He did indeed possess a special little gift. He built it up bit by bit, sometimes perhaps to the detriment of everything else, to the point where it dominated other explorations that he attempted in vain. He wasn't always a stylist, sometimes he even lacked that quality. As a draftsman, he had a hard time depicting the fingers on a hand without being able to retouch a brushstroke, as was his natural tendency. As a colorist, he was not always successful in balancing his chromatic ranges—he sometimes pushed them to acid tonalities or diluted them to the point of dullness. But always and everywhere the beloved substance of paint is present, solid and durable, manipulated with unbridled passion and ready for the magistral patina of the future. And yet what would Vincent not have given to actually draw, draw in keeping with his artistic vision and the reality of things!

I can picture him at Cormon's place in the afternoon when the studio was emptied of students. It became like a monk's cell for him. He'd sit before a plaster cast of a

classical sculpture, copying its beautiful forms with an-gelic patience. He wanted to seize its contours, masses, and reliefs. He'd correct his work, resume it passion-ately, rapturously, and end up digging a hole in the paper with the force of his erasures. This marvel of Roman art that he was confronting represented everything that his Dutch temperament opposed. But he was undaunted by the challenge he was assuming. He found his way more quickly and easily among the impressionists and the free rein they gave to expression and facile lyricism. He was more challenged by the calm perfection revealed to men of serene natures in civilizations that are close to nature and philosophy.

Vincent grasped all of that very quickly. There he was, leaving Cormon's and abandoning his ambitions of draftsmanship. He no longer preoccupied himself with drawing from antique models, far less with paint-ing them as he had done at the behest of the temporary patron he had chosen for himself—nude women amid imaginary exotic carpets, odalisques posed in a seraglio wreathed in mists. But as he rejected the pursuit of clas-sical art, all the more did he strive to be French.

Following the impressionists, pursuing their shim-mering example: "We're working on a French Renais-sance," he wrote to his brother, who, at his urging, was exhibiting Monet at Boussod. "And I feel more French than ever at this task. We are in our homeland now." It was all true, in fact. Vincent was becoming French, paint-ing Montmartre and its little urban gardens, the Moulin

de la Galette and its outdoor dancehalls. He even strayed as far away as Asnières in his excursions and stayed on the Île de la Grande Jatte, where Seurat was pursuing his schematic experiments.

He'd set off with a large canvas hoisted on his back; then he'd divide it up into so many boxes to accommodate the subjects he encountered on his excursion. He'd return in the evening heavily laden. It was like a little itinerant museum where all the emotions of the day were captured. There were pictures of the Seine's inlets full of boats, islands with blue swings, smart restaurants with multicolored awnings, pink oleanders, abandoned nooks in parks, and properties for sale. These works emanated a springlike freshness conjured up at the tip of a brush, as if slipping away with the fleeting hours. I relished their charm, all the more because that's where I lived at the time. These places were the destinations of my own solitary promenades, and he conveyed the mood I sensed there. Vincent often visited me in the wooden studio built in the garden of my parents' house in Asnières. While we were working there together on Tanguy's portrait, he started one of me as well. But he got into a quarrel with my father, who rejected his advice and plans for my future. He became so infuriated that he abandoned my portrait and took away Tanguy's—unfinished—after hoisting it, wet with paint, under his arm. He took off without a backward glance and never again set foot in our house. After that, I'd visit the brothers in their apartment at 54, rue Lepic.

One evening, Vincent said to me: "I'm leaving tomorrow. Let's arrange the studio together so my brother will think I'm still here." He nailed his Japanese prints to the walls and propped canvases on the easels, leaving others heaped in piles. He put a bundle of things together for me. When I unrolled the package, it was full of Chinese paintings that he had discovered and rescued from a *brocanteur*'s stall, wrapped up with other purchases he'd made. He then announced that he was leaving for Arles in the Midi [South], and that he hoped I'd join him there, because, he said, "The future studio must be established in the Midi." I went downstairs and accompanied him as far as the avenue de Clichy—which he so aptly called the "little boulevard"—and we shook hands. And that was the end, I never saw him again. I was never again with him save in the presence of death.

The letters I am reprinting today in their entirety (because only excerpts of them were given to the *Mercure* earlier) were the tie that united us. They allowed us to be friends, to get to know each other, during this separation.

He enjoyed writing to me at length. I was, I believe, his only close friend, after Gauguin. I've seen the letters Vincent sent to him, and they are shorter and more formal. Gauguin was older, and in Vincent's view occupied a more senior position. He had known the impressionists and struggled with them. He didn't really open himself to anyone but me. I was fifteen years younger than he, and although he spoke to me seriously about my works as an eighteen-year-old, he could assume a protective

and advisory role in the face of my youth. That is why, despite my complete independence from any influence, you'll notice that the tone of these letters suggests a person of ripe years addressing a young man.

Van Gogh didn't like to preach to those around him and did not really confront the stubborn absolutism of my youth. It so often happens that in the early part of our lives we lack a sense of tolerance toward life, and if anything struck me it was the confused variety of what he admired. We've seen from his letter to Aurier that he respected Meissonier and Mauve. We should add the names of Israëls, Ziem, Quost, Jeannin, Fantin-Latour, and plenty of others. Nothing was farther from my blind absolutism than Vincent's eclecticism.

Now I acknowledge his wisdom. The further I progress in the difficult career of a painter, the more I am impressed by the talents I encounter. They are so very rare! As painters have proliferated, their skills have gradually diminished, perhaps due to their numbers. The path is so crowded with inane people and pointless things that I respectfully defer to even a suggestion of genuine competence, an unpretentious find, a steady and solid skill, a near-forgotten sense of good taste.

To study is to see, and seeing means being present every day to the limited number of beautiful things. The more I see, the more things that I naively admire disappear, giving way to the rare gems of human genius. When you reach this culminating point, the center from which all illuminating beams radiate, you may be blessed with

the reflection of the supreme star, singing full-throated praise for the Beautiful. By broadening your understanding of culture, you become more tolerant, that is to say, abandoning prejudices and freely expressing gratitude to those who provide an unanticipated pleasure.

While I was traveling in Brittany, lengthy and frequent letters arrived from Arles, where Vincent had discovered that "this part of the world seems to me as beautiful as Japan.... The stretches of water make patches of a beautiful emerald and a rich blue in the landscapes, as we see it in the Japanese prints." I responded at equal length, also filling my letters with sketches of my works in progress. We had embarked on a project of drawing as we wrote, with the same spontaneity as a Hokusai or an Utamaro.

It's true that we idolized these Japanese images. Van Gogh had purchased a bundle of them on approval from a country dealer and traded me several studies. We were continually nourishing our minds and eyes, drawing upon their inspiration. The Japanese influence on modern artists should not be underestimated. The study was useful and invigorating and led us to revive our awareness of interpretation and develop a decorative sense. It elevated its admirers from quotidian banality and the rote copying of their surroundings. Despite the risk of steeping ourselves in a form alien to every European tradition, we were in a good school. The very simplicity of the images was art pure and simple, and culture at its most refined. Style is its defining trait, color constitutes harmony, and distinction is its emblem. The

most extreme sophistication melds with the simplest of means. In sum, the ensemble is composed from these elements, and the routines of life never make a disorderly intrusion.

Perhaps the Japanese are the equivalent of the ancient Greeks in the Orient, where taste tends naturally to the flamboyant, the monstrous, and the grotesque.

The first group of pictures that Vincent sent from Arles was closely related to this art of the East. He entertained himself by deploying motifs in the canvases using various techniques seen in these prints. When he painted flowering trees, it was an homage to those Tokyo painters who also painted them, but he added to his versions the special qualities of his own medium, which in this case was oil paint, an entirely European invention. He created a version of Japonisme that was highly pictorial, with an abundance of impasto, focused on a material instrument, the brush with which he transposed it. This is what made Rembrandt's fellow countryman so original—Van Gogh, a scion of the Dutch school, was now applying the principles of the Northern masters to a vision derived from Fujiyama. It's said that when Claude Monet was traveling in Holland, he came across a Japanese image at the home of one of his hosts. It inspired him to begin the series of works that brought him fame and had such a powerful influence on modern painters.

I don't know how much credence can be attached to this old tale. Whatever the case, we can but admire the wisdom of Van Gogh, who, having been temporar-

ily seduced by the impressionists, returned straight to the source from which they had emerged and learned the necessary lessons there. A true Dutchman would not scruple to open his mind to the East. When I later visited Holland, I was struck by the interiors. They were illuminated through radiant yellow curtains with large foliage patterns from Java, decorated with blue pots rivaling those of China, and blessed with an abundance of windows drinking in the light. I must confess that I began to perceive Holland as closer than we French are to those fairy-tale Eastern lands of color and clarity. We have become a stunted nation, prosaically bourgeois, with little heed for sumptuary order and elegance. Our most important personages have their dwellings decorated by carpet sellers; our moguls are idiots. We cannot imagine the Useful without differentiating it from the Beautiful. We frantically pursue the latest styles, which often result in nothing more than the ruination of some greedy tradesman. We mistake luxury for art and the ponderous for power. Our cities are overwhelmed by rubble, our gardens are disappearing, and our interiors are turning into cluttered beehives. Alas, how far removed we are from Eastern philosophy and Dutch common sense. We have no idea how to renounce material things, and we do not know how to live harmoniously in the simplicity of what is radiant and natural.

I recall The Hague's stately avenues bordered with age-old trees and patrician houses that seem like high-sided ships moored there for centuries. I remember the

shaded canals of Delft and the picturesque clutter of little houses in Dordrecht mirrored in the still waters. Such a sense of repose, such an image of a well-lived life, welcomed and accepted without pointless stress, in the serenity of an inward dream that does not underestimate the charms of reality.

Vincent was a native of this enlightened nation, and this is why he reasoned so rightly and saw so deeply.

However, the solitude he encountered in Arles weighed on him with the approach of autumn. The locals seemed somewhat hostile, probably because of his odd mannerisms. He complained that he couldn't find local models, although the Arlesian physical type appealed to him. Also, he had no money. He worked all the harder when the support payments sent by his brother were exhausted. A deep dread was born in him—the fear of burdening his brother with his financial needs. Despite his resolution to say nothing about it, he sometimes revealed his concerns. "I'll return the money or turn up my toes." I can think of nothing more touching, more noble, more heroic than this cry. Perhaps it contains the truth about a suicide that would later so dismay the little town of Auvers.

Meanwhile, Gauguin had withdrawn to Pont-Aven. Unable to extricate himself from debts that grew greater day by day, he received a letter from Van Gogh beseeching him to visit. He also made pressing requests for me to come, too. To my great regret, I was not able to carry out this hoped-for plan, and Gauguin left on his own.

The letters that he wrote to me from Arles suggested that he did not have a good understanding of Vincent's nature. He even claimed that Vincent enjoyed everything that caused him suffering and focused only on what displeased him. "Vincent and I don't agree on much, above all when it comes to painting," he complained to me when he'd just arrived. "He admires Daudet, Daubigny, Ziem, and the great Rousseau, all of whom I have no feelings for. On the other hand, he detests Ingres, Raphael, Degas, all of whom I revere. So I respond, 'Right you are, Captain,' just to have a little peace. He likes my pictures very much, but when I'm working on them, he is always finding fault with me about something or another. He is a romantic, while I have an impulse toward the primitive. From the coloristic point of view, he sees the risks of impasto in Monticelli, whereas I detest the tiresome business of brushwork, etc."

Gauguin had only been down there a couple of months when he suddenly returned to Paris. I found him very calm and collected with Émile Schuffenecker toward the end of 1890. A catastrophe had occurred in the town of Arles. Seized by some incomprehensible fit of madness, Vincent had cut off an ear and taken it to a girl he knew in a local brothel. Thinking it was a sentimental token, she had opened the package; at the sight of the blood, she fainted dead away. Van Gogh fled home to bed in his little yellow house on place Lamartine. Informed of these events, the police opened an investigation. Gauguin had been away that night and had no

inkling of what had occurred. When he returned to the little house early the next morning, he was arrested by the police commissioner who accused him of having killed Vincent. Fortunately, Gauguin is a man of sang-froid and persuaded the commissioner to pursue his inquiries and open the house door. It had to be forced as Vincent had locked it when entering. When they entered the place, there was blood everywhere. They got to his room and found him on the bed. The wound had bled so heavily that he had lost consciousness. "You can see he's dead," cried the officer. "Shake him then," said Gauguin. Upon being shaken, Vincent came to himself and explained everything. They bandaged him up and wrote to Theodore, while Gauguin returned directly to Paris.

What had been going on in Van Gogh's head?

The solitude in which he lived had habituated him to a fanatical concentration. His mind was swamped in social, religious, and mystical speculations. While he was pursuing harmonies in his palette, he was constantly worrying over daily things, all the more because he was turned in on himself. The devout young pastor who had once wished to convert Belgian Catholic miners to Protestantism resumed his dreams in the person of the solitary artist—but no doubt in a more freewheeling manner than had been advocated in Dutch theological courses.

The letters he sent me from Arles were often a kind of Christian discourse where pictorial naturalism appears as a positive complement to the religious idea. "Christ works in living spirit and flesh," he wrote to me. For him,

that suggested the practice of impasto painting, which he refers to in the same letter when speaking of Rembrandt and Frans Hals. He had resumed his Bible reading and mined its symbols. Among these, he was struck by those that referred to the spirit—fish, among other subjects. He went about drawing them on the walls of his house. Yellow, the color of divine brightness, also fascinated him. "I've painted the little house where I live in yellow," he wrote, "because I want it to be the house of light for everyone." Vincent had been led to these illuminations by the silence in which he had wrapped himself, almost by force. No doubt, among the people he saw in the Midi during his travels from Arles to Tarascon he encountered very few with characters who were congenial to him. They would have been completely the opposite of the spiritual nature of the northern European, who insists on driving home every form to an idea and every idea to its central focus: reason.

Van Gogh had been led astray by the naturalism of Zola's school in Paris, and by the long-since abandoned sensuality of impressionism. Gradually, in isolation, he resumed contact with his distant antecedents and again became a Dutchman in a Latin setting. The conflict created by such unexpected contrasts is often resolved in some form of private tragedy that unfolds before the public eye.

Such was Van Gogh's state of mind when Gauguin joined him in Arles. The lengthy conversations, the fierce confrontations, soon led to an outbreak of critical

overexcitement. It was destined to explode, in the midst of some transient crisis, into complete madness. The insanity expressed itself in the incomprehensible act—so bizarre and distressing—that led him to carry his amputated ear to a girl in a whorehouse. When lucidity returned, he himself spoke of it later with complete stupefaction and a kind of rationality. He asked his brother what he thought would be the surest way to take care of himself so that potential future crises would not take him unawares. Henceforth, he would struggle in this hellish bond that terrified him, even when he was in control of himself, with the fear of plummeting into the shadows of obliviousness and insanity. That was indeed the most painful test of his sadly tormented life, and I certainly do not describe it without sharing in his horror. I understand how much the incompleteness of his work, marked by so much unquestionable genius, demands indulgence and forgiveness. You have to comprehend the impatience of a being who sees the paradise of spiritual equilibrium before him, and who fears he will be denied entrance because the gates are only halfway open. An angel grasping a double-edged sword seems to be always threatening to close them pitilessly to his gaze and footsteps.

It was a singular form of despair. Only those who have experienced nightmares and illness will comprehend it in all its horror.

Intervals of lucidity soon returned, as demonstrated by Vincent's letters to Theodore. It is remarkable how he

was able to assess his state of health and coolly gauge his own mental stability. He deplored what had occurred, almost as if he had had nothing to do with the affair; he regretted the abrupt departure of his friend Gauguin, whom he commended warmly to his brother. What he mourned most deeply was the vision of a communal studio in the Midi, which he had hoped to share with other painters. When he returned to the yellow house, it was derelict and permeated with mold. Rain had seeped in, destroying the decoration he had created with so much care and hard work. He wept with disappointment, feeling that his life was over, that his future was shattered, and that henceforth, helpless in the face of his unpredictable mental condition, he was accursed. It was then he wrote, crushed by despair: "Now, myself as a painter, I'll never signify anything important."

In that moment, a sense of fatality claimed its victim and engulfed him. Ah! If only his faith could have reignited the torch of Hope! Devoid of any goal, he resigned himself to entering an asylum in Saint-Rémy near Arles.

The young doctor there took an interest in his patient and encouraged him to work. Vincent painted in the asylum's park, in the sickrooms, and in the surrounding countryside. He created large and beautiful charcoal drawings of woodland paths and vases overflowing with wilted flowers. A sense of melancholy replaced the sunny exaltation that had guided him in his early days when his art was still completely impressionistic, in the part of the world "as beautiful as Japan." Paris was no longer

agog with rumors about his ear, so his obsession with ex-
plaining himself diminished. He gradually retreated into
his own world, withdrawing from naturalism and devel-
oping a touching affection for daily life and living crea-
tures. A mailman, a Zouave, an invalid, a porter, or a hos-
pital intern—all inspired him to draw studies and create
paintings. Matters of technique concerned him less now.
He painted better because he was no longer fixated on
ranges of color, instead following his private vision. His
mysticism inclined him toward a sense of compassion
that drew him to suffering fellowmen, inferiors and the
poor, victims of inhumanity, the sick and the lost. Even
in depictions of nature, he expressed tenderness for an
old tree covered in ivy or an empty fountain in the park,
where leaves lie heaped like a faded cloak.

Night seemed to interest him more than day, and he
paced along the banks of the Rhône beneath flickering
lights and twinkling stars. He made those stars swirl in
their dark wilderness; he traced the sickle of a crescent
moon over silhouettes etched by shadow. The bleeding
twilight and the anguish of the tortured rocks and crags
held an irresistible attraction for him. Everything that
appeared in his agitated canvases seemed to be seized
by spasms and unease. He was deeply committed to a
quest for precision in these works, for firm drawing and
decisive outlines, for a powerful feeling of harmony, a
sense of solidity. I believe he had never painted so well
or so boldly.

He made copies of Delacroix, Millet, and Daumier,

which provided distraction and satisfied his perpetual need for study. He handled them freely with a distinctively personal quality, but he did not neglect the challenges that had preoccupied those masters. He seemed to borrow the foundations of his harmonies from Delacroix, his biblical love of the land and its laborers from Millet, and his powerful lines and well-defined contours from Daumier. And Gustave Doré captivated him with his inspired imagination, expressing all those subtleties that escape the common gaze—the magnificent poetry of humanity's tragic spectacle. This passionate artist was treated so unjustly. A superb illustrator, he gave the legend's pencil to France. He fixed forever in our minds images of the characters of no physical reality who so vividly inhabit epic poems and satires. Vincent found this *Ronde des prisonniers* [*Prisoners' Round*] in the pages of his work. It seems to depict his own spirit sunk in an abyss of anguish and distress.

During this time of exploration (a period fertile with innovation), pictorial technique was a compelling question that preoccupied Van Gogh, as it did all of us. He was enamored of the impressionist palette, which was devoid of the blacks and earth tones he was accustomed to in Holland. We saw him consult medical research, raising questions around Pissarro and Signac and the theory of complementary colors and the division of tones. He had no sooner left Corman's studio, where he strove in

vain to improve his drawing technique, than he began working in broad strokes of pure color, raining them down on the canvas following Seurat's innovative approach. When I first met Vincent at Tanguy's, he took me to see his apartment on rue Lepic. All of his experiments were on display there. Dutch canvases in the style of Rembrandt, proudly painted and with a powerful impact; self-portraits in stripes like the one with the straw hat at the beginning of this book, which dates from that period; the banks of the Seine, the forest floor in the pointillist style; the Moulin de la Galette in browns and blacks. When visiting Arles shortly thereafter, he wrote: "I follow no system of brushwork at all; I hit the canvas with irregular strokes which I leave as they are, impastos, uncovered spots of canvas—corners here and there left inevitably unfinished—reworkings, roughnesses; well, I'm inclined to think that the result is sufficiently worrying and annoying not to please people with preconceived ideas about technique."

Later, realizing the shortcomings of a palette limited to six or seven colors, he turned to black, that color so detested by the impressionists, and to white. "I'm going to put the blacks and the whites boldly on my palette just the way the colorman sells them to us, and use them as they are." Indeed, why banish these two complementary colors that the Japanese have taken as the basis of their artistic harmonies? Vincent fixed one attentive eye on nature, with the other focused on the Eastern masters, adding: "When I see in a green park with

pink paths a gentleman who's dressed in black, and a justice of the peace by profession ... who's reading *L'Intransigeant*. Above him a sky of simple cobalt. Then why not paint said *shustice of the beace* with simple bone black and *L'Intransigeant* with simple, very harsh white?" However, to use this technique effectively, you have to go back to the Japanese prints, with their flat applications of color; these act upon the eye, and, as in nature, confer on this raw black and pure white certain qualities of color that are determined by their intensity and surface area. Thus, raw black paint, laid down with no blending, and white that remains untouched by combination with any tonality whatsoever, seem to be neither one nor the other. They harmonize with their surroundings by the very rightness of the colors applied around them. Little by little, this reasoning led Van Gogh to retreat from impressionism. It is a narrowly defined theory to which no real artistic temperament should be confined, or subjected to its tedious routine. Vincent espoused a noble openness of spirit, inspiring his admiration of Fantin-Latour, "someone who hasn't rebelled, ... one of the most independent characters in existence."

There is an important distinction between systematic insurgency and independence. There is a gap between the two. Consider a tormented artist, eager to invent a personality for himself based on free-floating contemporary ideas and a certain basic originality. He would always rebel against the confinement of ideas and harken to the lark's lyrical, lively song as it hails the dawn. If

I were to commend just one aspect of Vincent's nature, it would be the wisdom of his discernment. Although he briefly allowed himself to be swayed as an adherent of impressionism and scientific norms, he cannot be faulted for wishing to be a man of his time. He did not succumb to that low instinct typical of mere imitators: incapable of rousing any inspiration from within themselves, they go and beg their followers to pave the way for their work and their sterile pursuit of success. Perhaps in 1885 to 1888 there was a certain heroism in proclaiming oneself a partisan of new theories; there would have been wisdom in desiring to understand, experiment, and create according to their precepts. But there is a greater form of courage, and that is what distinguishes Van Gogh in our eyes. He had to liberate himself to go further, taking painting and expression the next step beyond the constraints of science. Vincent expended himself freely, experiencing the exaltation of ten fervently lived lives. He overstimulated himself in every way possible to achieve these sensations. No doubt his need arose from an abundance of thought and interpretation, which he now had to abandon in favor of a kind of lyrical ecstasy. As Vincent blended reds and greens, blues and oranges, violets and yellows, coolly rational analysis could have reduced his efforts as an artist to schoolboy homework. Van Gogh reacted against these restraints, valuable in themselves, but artistically chilling. Instead, his thoughts and sensations overheated in the southern sun, with the contemplation of Japanese

artists and with solitude, that wise mediator of passions. He achieved such progress between 1887 and 1890! From the complicated arrangements of colored bands that marked his studies of Montmartre, he arrived at a synthesis of almost flat colors modulated with touches of gray, which he accented with vigorous slashes of black like the lead in a stained-glass window. His drawings, executed in charcoal, were merely a prelude.

"These drawings are done with a reed cut the same way you'd cut a goose quill," he wrote to his brother Theodore. "I plan to do a series like that.... It's a process I already tried in Holland in the past, but I didn't have as good reeds there as here."

His drawings! We do indeed need to speak of them. This was another instance where he completely went beyond the conventional approach to depicting the objects before our eyes. It was a bold attempt to translate the effects of color. Using bands, dots, and lines applied to the forms in the most expressive manner, he vividly conveyed the brilliant vision that his imagination gleaned from sights around him. He truly yearned to draw with the same facility we have in writing. He preserved the conviction, so timeless and so true, that drawing is the foundation of art and that it is only through draftsmanship that pictures come into existence. He first concentrated on building a framework of bold lines to discern the fundamental balance of harmonies presented by nature. Then he elaborated the arabesques with his vibrant touches, strokes, dots, and stripes, all intended to give

the composition a sense of motion. It was all done by impulse, without cold calculation, with the unerring intuition of a passionate soul, a fervent heart.

And besides, what did these classifications really matter to him? He believed that a change was occurring in art, but where would it come from? He had no idea, but his sense of wonder knew no bounds. "We'll always retain a certain passion for impressionism," he declared to his brother, "but I sense that I'm returning more and more to the ideas I already had before coming to Paris." He added these telling words:

> When I wrote to you that we mustn't forget to appreciate what's good in those who aren't impressionists, I didn't exactly mean to say that I was urging you to admire the Salon beyond measure, but rather a heap of people like, for example, Jourdan, who has just died in Avignon, Antigna, Feyen-Perrin, all those whom we knew so well before, when we were younger, why forget them or why attach no importance to their present-day equivalents? Why are Daubigny and Quost and Jeannin not colorists for example? So many distinctions in impressionism did not have the importance one wanted to see in them. Crinolines also had something pretty and consequently good about them, but anyway the fashion was fortunately short-lived all the same. Not for some people.

The concluding comparison is a bit obscure but does not impinge on the fact that Van Gogh had talent. It pleased him to believe that he found art in the present moment. And that is the opinion of an artist in the true sense of the word. Isn't impressionism a fashion, just as the crinoline was? Is the practice of painting in the light or *en plein air* reserved exclusively to the present moment? Clinging to such notions is the height of obstructionism. Vincent was careful to avoid falling into that trap. The poet's lyre requires every chord to be played on its strings, and it has no limitations save for sterile repetition. I'd like to again recall Vincent's wise words cited earlier in his letter to Albert Aurier.

Condemning the routines of the École des Beaux-Arts, only to limit yourself by other strictures that are even more confining—what a melancholy victory! I realize it is the source of our current malaise. Nevertheless, I am happy to recall that I often supported the theory that my friend expresses in his correspondence.

There is absolutely no law that a certain technique is the essential truth of art. We have all seen fruitful attempts throughout the centuries degenerate into systems that are more or less destructive. Tintoretto's style morphed into the writhing specters of El Greco, Michelangelo's into the excesses of Carracci. Ribera's chiaroscuro became Valentin's impenetrable night, and the clarity of Rubens the specious artistry of Boucher. Primaticcio was mocked by the rigid poses of David, and Veronese's colors metamorphosed into theatrical

scenery in the frescoes of Tiepolo. Just as divine revelation is altered on human lips, the revelations of geniuses are imperceptibly changed from gold to lead by their followers' heretical manipulations. These counterfeit creators, desperate to produce the illusion of talents they are merely imitating, succeed only in copying their faults and overplaying their distinctive characteristics. Little by little they despoil the true value of a masterpiece, reproducing only its flaws. This is how, whether in a quest for recognition or due to an insatiable appetite for gain, the most enchanting harmonies have come our way as falsified replicas. This is how—via Ingres—Raphael's Madonna ends up in the pious precincts of Saint-Sulpice.

It is vain to become attached to the arbitrary form of a pictorial technique. Painting light or painting dark, in flat applications or shimmering dots, is no guarantee of an artist's genius. The genius knows how to pluck every string of the lyre and play every chord on nature's vast keyboard.

I should deal with a question pertaining to painting that has created great divisions among artists. It has caused much dissension and deplorable error.

In his letters, Vincent often used terms of this type. They—Rembrandt and the old masters in general—"worked with values" but we contemporary artists work "with colors."

Having worked with colors for a long time, I would like to express my views on this contention.

Art, however great its unity, is always divided into sectors that the artist learns, studies, and develops. Art history has seen a succession of schools, each putting more or less emphasis on one of these aspects, and this distinction differentiates them.

Eschewing simplicity, desirous of being celebrated for a specious kind of originality, painters of every era corrupt the spiritual works and laws with extravagant fantasies. They may distort their draftsmanship in favor of a stylistic device; they may glorify color to the detriment of values or values to the detriment of color. In contrast, for the great masters and artists of the highest caliber, there is a close union of all artistic elements. They are so well balanced that they dissolve into a superior form of expression, to the point where we forget the practical aspects of the métier—we are elevated to a sublime sense of harmony and perfection. Neither da Vinci, Raphael, nor Titian—however much we may admire one of their qualities more than another—dissociated the branches of art from one another. They have, in contrast to the lesser painters cited above, initiated us into the mystery of Beauty by their understanding of unity and perfect equilibrium.

In contemplating these noble exemplars for whom art, like nature, seems to be a magically divine essence with no human fallibility, we elevate our consciousness. We aspire to the supreme synthesis while condemning—

by this self-evident proof—the paradoxes that tend to replace one aspect of art by another. Such violations disrupt artistic unity in the guise of novelty.

The most damaging propensity for an artist is the temptation to ignore the inescapable artistic laws that he is studying. In what concerns us here, he may neglect values, seeing only color with no idea of what replaces it. Values are degrees of darkness in a picture that are determined by its particular lighting effects. These effects should reveal objects in relief, as well as perspective, ground, the texture of fabrics, air, and light.

Photography relies on values, and it gives an excellent sensation of actuality. To summarize, values can be defined as the relative strengths of shadow. White can in fact be found in every aspect of a drawing, and a line drawing, the contours of which contain no degree of black, is always flat. On the other hand, shadow adds a magical effect in determining the spiritual significance of objects and places each thing in its plane with greater or less emphasis. This conforms so closely with our senses' perceptions that we are always much more struck by the effects of nature than by its colors. Above all, we see objects by contrast, by the actual play of light. Objects appear to us to more or less dark silhouettes on light grounds or more or less light silhouettes on gray or dark grounds. This effect of contrast—developed through art—makes a compelling picture.

The desire to make color—color that has been reduced to the lightest tones on the palette—play the role

of values is like trying to replace night with day, disrupting its qualities and properties. Color, or to put it more clearly, coloring, or to put it even more clearly, bright colors, prismatic colors—those that are advocated by partisans of color over value—are no more than clothing for a form. This clothing is modified by the position of the light and depends on the nature of the form: cylindrical, cubic, sinuous, flat, slanting, etc. Having considered these factors, one realizes that the error under discussion can have very extensive consequences: anyone whose action destroys the values of a picture will necessarily attack its forms, as values are nothing more than the play of light and shadow on the form itself. I am not claiming that there are no degrees of color. Color values result from the addition of more and less white made by the painter to the colors he is applying. But these color values are nothing more than a second addition made to the first interventions, those of effect and relief.

The impressionists ran into this problem and failed to reckon with it. They had blindly adopted the palette of the prism—yellow, orange, red, carmine, violet, blue, green—without considering anything other than its dazzling impact and the findings of research laboratories. The issue arose in their early works. These beliefs were then reinforced as their most obstinate students immersed themselves in foolish and wasteful experimentation. Today it is accepted as an uncontested fact, proclaimed by the youthful school of inexperience, that values reside entirely in color. Regrettably, I who

write these lines was among the first to disseminate this error.

In fact, only abstractions can produce art. The line is foremost among these abstractions, for it does not exist in nature.

Architecture, the basis of the arts, can only express itself in lines, and it is perhaps in lines that its greatest beauty resides. Study Egyptian temples or the Parthenon to observe the very simple harmonies of straight lines. The curve came later, casting architecture into disarray. Only the East, with its rich imagination, understood how to employ curvilinear forms. Thus line is the foundation of art and we see it move—as sinuously as life itself—into sculpture. It triumphed with the Greeks. Painting is in turn only harmonious when, considering the picture as an architectural surface, it incorporates the ideal correspondences of the line. Raphael was the master of this magnificent technique. Since the line does not exist in nature, there is in fact nothing but contrast. We are thus forced to concede that abstraction is at the foundation of art, that art is entirely an abstraction. It follows that values and lines are merely conventional ways to depict shadow, and by these shadows, the light that presses around the contours of the line. Since shade and light are the elements that strike us most in our observations, it is primarily through them that we represent relief and planes of objects in drawings.

The impression of shadow cannot be obtained other than by the diminution of light, because that is what the

phenomenon consists of. Since the absence of light is the absence of color, it follows that shadow is the diminution of color.

It might be objected that shade may be composed of all colors, because the shaded parts of an object are subject, due to the absence of direct light, to receiving a considerable number of reflections from surrounding colors, and that these reflections color the shadow. I acknowledge this, having written myself that the transition from one tone to the next is given by the reflections in the shadow. But I maintain that the more there are reflections of a variety of colors in these shadows, the darker they are. It is easy to demonstrate this by experimenting with blending colors on a palette. The more the colors are mixed on the palette, the darker they become. The same thing occurs in a shadow that is full of reflections. The more it receives, the more it itself becomes darker (when I speak of color reflections, I am not speaking of reflections of light). It therefore follows that shade—which is the opposite of light and also of color (since the more pure colors are mixed with each other, the more shade is created)—is an inescapable necessity of form, because it expresses the relevant parts and thus contributes to giving it motion, life, and personality. This is not the case for color, which is incapable of producing, by the use of its pure tones, either a plane or a form. It allows only an outline, and that only on the condition of an abrupt contrast such that a light color—yellow, for example—is cut off from a deeper tone such as blue or carmine. It should

be noted that these colors, more saturated by nature, give an illusion of values in this situation; but this illusion of values, while easy in a simple canvas, cannot bring the desired degree of perfection to a completed picture. It would instead be a constant impediment.

The artist must therefore blend his pure colors to the point of descending into darkness or paint a Japanese *crépon*, in other words, merely imitate the procedure of printmaking with oil paints. Why not then approach it straightaway with watercolors?

When he was still under this false impression, Vincent himself wrote me that it seemed to him that the Japanese were making paintings with a pen. Admittedly he said that while reconsidering the magnificence and perfection of Dutch paintings on museum walls. And who would not agree? You can indeed believe in various chimerical notions when you are far from any point of comparison. But if you chance to encounter—through your eyes or through memory—one of the splendid achievements of artistic genius, you immediately sense the error about to engulf you and the quagmire where you have ventured. Unfortunately, you do not always benefit from this lesson because the mind is captive to its illusions.

Thus values, the forces that are the bedrock of a painting, are denied. One might have supposed that their abandonment would have resulted in the triumph of color. And was this object of desire attained? We must consult the masterpieces to know the answer, and following this consultation we may decisively reply, "No."

What's more, we can state that the attempt is the origin of the incompleteness that characterizes our most promising artists. These include Manet, Cezanne, Renoir, Monet, Sisley, and, more generally, all those who as a group have scorned the pictorial unity resulting from the generalized lighting of the whole by the effect.

Van Gogh was taken in by this delusion, which he wrongly attributed to Delacroix—for no one took more care in establishing shadows than Delacroix. He used earth tones, ochers, and blacks in his work so as to tightly bind all the elements together. I would even say that he pushed his determination to give the effect of relief so far that he developed a typical fault of deformation.

In truth, only young men beginning to paint and aspiring to novelty can allow themselves to be influenced by these chimerical views. They soon feel the need to penetrate the hidden reality of art rather than just toy with its surface, and they leave aside fruitless discussions that serve only to promote idle debate.

Art is based on inescapable abstractions that are the condition of its life and health. Line, contour, values, color—so many aspects of its divinity cannot be denied without engendering heresies that are fatal for it and its partisans.

Those who profess only to the cult of personality are grossly mistaken with regard to Vincent if they believe he should be judged by this vulgar standard. Van Gogh's

originality was indeed striking, and it should not go unacknowledged or be dismissed. It drew its powerful affirmation from the exaltation of his intelligence and his senses. Some might suppose that his goal was to achieve the triumph of individual expression.

However, Vincent van Gogh was not persuaded that a new art different than that of the ancients had been created. Instead he believed that an important discovery had been made, that of color theory. He wanted to work "toward a French Renaissance," which he supposed would be made possible following this scientific revelation. Certain technical basics seemed to him to have changed, whence would arise a new form of expression. Taking history as an example, he speculated, "The paintings that are necessary, indispensable for painting today to be fully itself and to rise to a level equivalent to the serene peaks achieved by the Greek sculptors, the German musicians, the French writers of novels, exceed the power of an isolated individual, and will therefore probably be created by groups of men combining to carry out a shared idea." Eager to unite diverse abilities in a common effort, he explained how one artist might have a masterly command of color, another a great talent for draftsmanship, and another an imagination capable of conceiving striking compositions.

He was insatiable in appropriating the qualities he encountered in his peers and studied them avidly to unlock the mystery of their discoveries. He copied Daumier, Millet, Delacroix, and even his friends Gauguin and me.

I do have to include myself, because it's true—his letters very often testify to the use he made of my early work. What's more, it delighted me to win his admiration back then; it was very reassuring and helped me to develop my skills. Sarcasm and incomprehension were my lot at that distant time. Let those desirous of easily won success try to follow the road that Vincent, Gauguin, and I trod years ago; our path was consecrated with sadness and suffering.

The notion of an association of artists capable of executing works of art together ended in failure, although Van Gogh cultivated the idea with loving care. He thought of opening a sort of refuge in his home in Arles as its haven. It would be both a safe house and a studio for new ideas.

Gauguin's indigence forced him to accept this offer, and he was the first to experience the communal existence and work that became the common property of all. I had already come up with the idea in Pont-Aven. My reward was to see Gauguin monopolize my technique and abscond with it to Arles. This matter has incited lengthy debates among people with an interest in sustaining falsehoods, and it always satisfies me to go back over the principal events of my artistic career. Here I'll do no more than cite dates.[1] Look at the pictures painted by Gauguin in 1888 (they're all dated) before my arrival. They differ noticeably from those painted later the same year. Initially laboriously executed in colored rope-like forms, they are woolly, matte, dull, and grayish; then all

of a sudden they are liberated, simplified into large areas of flat, vivid color.

Can there be a more persuasive proof, and how can this abrupt change, absolutely absent from my canvases of 1887, have left the slightest doubt on this question? I've said it before and I'll assert it again, when I returned to Pont-Aven in 1888, I made Gauguin's acquaintance and shook his hand on Van Gogh's behalf. I invited him back to my place and I noticed how my paintings made a powerful impression on him. I had arrived from the Channel coast with works executed over a period of four months of complete solitude. From that day on, persuaded by Van Gogh's idea—that everything had to be shared—I hid none of my research from Gauguin. There was one canvas I had painted from memory, *The Pardon at Pont-Aven*, that marked his abrupt abandonment of divisionism and the adherence to the school of synthetism, that is, the use of flat areas of color. His *Vision of the Sermon*, later hailed as a breakthrough, was simply an imitation of my *Pardon*. I even allowed Gauguin to use colors missing from his palette, permitting him to borrow from mine.

Gauguin was so taken with his canvas of the *Pardon* that he wanted to keep it and take it with him to Arles. Vincent saw it there and wrote to me: "I would long to see things of yours again, like the painting of yours that Gauguin has, those Breton women walking in a meadow, the arrangement of which is so beautiful, the color so naively distinguished." Later, when Van Gogh's brother

Theodore summoned me to hang the deceased artist's paintings in his apartment, Theo showed me a copy that Vincent made in Arles when he saw the painting I had done that was in Gauguin's possession. That didn't prevent an unscrupulous dealer from later displaying it in his gallery without indicating that it was executed after one of my works, and to list it in the catalogue as a work by Van Gogh. For a long time, this dishonest tactic caused my work to be thought of as a copy of Vincent's, and it completely disgusts me. But should we be shocked by anything in this era of corrupt commercialism?

So the notion of an artistic cooperative is repellant to me. Even if it has not suppressed any aspect of my inner nature, it has brought plenty of bitter disputes and absurdities.

People I'd thought of as friends in the younger generation, whom I'd generously offered help build a reputation, turned against me with indescribable bad faith. Leaving this aside (they were novices still suckling at the teat of the École des Beaux-Arts at the time), they sided with Gauguin on a point on which they were utterly ignorant. Certain critics, who I won't name, arranged matters to deny me any hint of good faith; others admitted, it is true, a conciliatory initiative from me toward Gauguin and of Gauguin toward me. The truth remains that I had only one teacher at that time. It was Paul Cézanne, and it was through me that Gauguin, who had neglected him, relied on my own research, and adopted his methods without fully understanding them.

Pardon this digression, which I'll end here. Vincent was older than I was. I felt profound affection for his kind heart, but he dragged me into a communistic endeavor that repelled me (my taste for solitude being the proof of this proclivity). I yielded to his importunities and advice because art has always seemed to me a sort of religion that should exclude egotism. I would have done anything for its glory. I was ready to pay any price, even renounce my life. My naive self-sacrifice exposed me to entanglements that still cloud my existence.

The life that Van Gogh and Gauguin shared was hardly a happy one. I acknowledged in the first part of this introduction that this relationship led to a violent clash rather than a peaceful coexistence. In a letter Gauguin sent to me, he acknowledged his differences with Van Gogh—he loved everything the latter detested, and vice versa. There were real disputes when they were painting side by side, and the two were in constant conflict. Van Gogh often conceded a point, but he suffered inwardly, because he realized they would never work in harmony. There was an incessant clash between opposing temperaments, one a Dutchman, as explosive and enthusiastic as a man of the Midi, and the other a Frenchman, cold, restrained, and self-willed as a man of the north. That conflict no doubt precipitated Vincent's madness. Only one point brought them together: the general contempt with which their work was regarded— and destitution.

Van Gogh was a good man. Admittedly he was prone

to violent fits of anger, but he almost always regretted them, and his letters of apology and protestations of friendship revealed his nobility of spirit. His innate religiosity conferred a kind of human superiority on him, insofar as it is the case that religion elevates the individual. Gauguin was a different story. The son of a republican journalist writing for the *National*, he had retained a narrow-minded arrogance from his class origins. No hint of spirituality altered his willful determination. He was an enlightened art lover as well as a self-aware artist. He acted in his own interest where he found it, with no concern for anyone other than himself. Starting as a painter late in life, he wanted above all to *coup de poing*. "Pack a punch"—it was a phrase he used often. It explains his art and associates with him exclusively the arbitrary aspect of his character and talent. His very being was based upon egotism. Later, under Vincent's influence, I encountered a Gauguin who was humane, evangelical, and symbolist. But these avatars never erased from my mind the man I met on my first trip to Pont-Aven in 1886. He was truly the authentic Paul Gauguin.

Even the most selfless efforts to create art in a spirit of collaboration are fruitless now. Artists reject the concept of unity; they are perplexed by the myriad unwholesome ideas that pervade our consciousness. Our ties to one another have been severed; man is ostensibly free and will perish, suffering in isolation. Nothing truly great can ever happen again, because the cult of individuality has slain unity. If unity is truly strength, we must

attribute the artistic poverty of our moment to this rupture of spiritual ties, which leaves us like scattered flotsam in its wake. Despite friendship, despite art, despite need, even despite our own best interests, our minds are increasingly divided. We live alone in a society that is the most populist and independent in the history of the world, and our genius has become an empty thing. This is the tragic outcome of all our labors.

Vincent was terribly aware of this. Emerging from the hideous nightmare of madness, he wrote to his brother Theodore: "That had an effect on me, not only the studio having foundered, but even the studies which would have been the memories of it damaged."

Then he turned to Gauguin's departure, their plans for a productive life together. Vincent said he had struggled in vain against inexorable forces. He felt a sense of regret, accusing himself of a character flaw because he had wanted to contravene the established order. In his fit of madness, he continued the struggle, wishing to defend himself but able to do nothing. Still, all his strivings had been devoid of personal ambition and undertaken on behalf of the artists he loved.

Such was the melancholy fate of Vincent van Gogh's idealistic plans, crushed by the narrow egotism of our time.

Committed to his art and his friends, he had aspired to establish a refuge where frustration and disappointment would have no home. He hoped for a spirit of collaboration among artists: strength would build and provide a foundation for the success that should crown

bold and worthy ventures. But in reality, he was engulfed in darkness. Even as the inexorable hand of madness gripped him, he was fighting, struggling on behalf of "luckless painters" and the doomed.

"If I were without your friendship," he wrote to his brother after this whole tragedy, "I would be sent back without remorse to suicide, and however cowardly I am, I would end up going there."

Sadly, he all too faithfully fulfilled this prophecy.

And now a word on this publication.

In 1892, a few years after Van Gogh's death, friendship impelled me to reveal the mind and spirit of the man who had been my dearest comrade. His understanding and steadfast affection had touched me so often. I told Paul Forte about the letters I had received from Vincent and shared some of their contents. He was initially attracted by the captivating drawings interspersed amid the writings, and then by the passages I read to him—so much so that he contacted Alfred Vallette, the editor of the *Mercure de France*, to share his enthusiasm. With his typical good judgment and initiative, Monsieur Vallette promptly developed a proposal for me to send him the letters for publication. "I'm told you have letters from Van Gogh, illustrated with drawings and sketches," he wrote, "that you are willing to have published. The *Mercure* was among the first to recognize Van Gogh, and it is also, I believe, among the French avant-garde publications

most read in France and abroad. Don't you think these letters would be best entrusted to us?" There was no need to ask me twice. In handing over the epistles of my misunderstood friend, I hoped to counter the world's shortsighted neglect of his achievements. After an exhibition that I had organized on my own, after the silence of comrades and the press, I tried once again to win Vincent recognition by revealing intimate aspects of his mind, his struggle, and his life.

His letters express what was most compelling about the man.

After reading them, you will have no doubts as to his sincerity, his character, or his originality. Everything is written there, pulsing with life.

However, these letters were confidences exchanged between one friend and another, mingling details from private life and those pertaining to art. Sometimes they showed the names of recipients, revealing the identity of his followers. A selection had to be made, so I delved into the collection, highlighting the passages most worthy of attention. It seemed best to extract their essence rather than publish them all at once. I hoped that prudent editing would achieve the goal of familiarizing the public with Van Gogh's mind and spirit. In publishing extracts in the *Mercure de France*, I reproduced nothing that might offend through coarseness of language or crudeness of expression. I published nothing pertaining to myself, giving only the initials of friends we shared at the time.

This reserve no longer serves any purpose. "Success" (this stupid word actually has some legitimacy here) has consecrated *Letters from Vincent van Gogh to Émile Bernard*. The recognition of the painter's correspondence has carried over to his works in German and Dutch museums. An edition of these letters, a historic landmark in contemporary art, has been published in Berlin. Perhaps others—also issued without my knowledge—have helped spread Vincent's reputation across Europe. Confronted with the growing desire among artists to learn everything about the life of Vincent van Gogh, it is time for me to publish his correspondence with me in full.

Here it is. This time I have omitted nothing.

It includes his mistakes in French, his constant repetitions of "here," "but," "there," "in so much as," "now," etc. The turns of phrase are often awkward, unsophisticated, or foreign. A thought may be reconsidered later the same day. His language, frequently radiant with tenderness, grace, and kindness, often seems to take wing. But sometimes it plummets into the vulgarisms you'll hear in Parisian studios, the argot of squalor. In my view, such language merits our sympathy and understanding because, despite some habitual lapses and excessive drinking, his gritty, realist prose often radiates beauty. The reader finds himself in a sunlit meadow full of flowers, in a silent city where the sky is a wonderment of stars, in an unknown world resonating with the words of Christ, where the symphony of art resounds. Deeply

human and profoundly spiritual, Van Gogh mingled the ugliness of hell with the spiritual graces of Redemption and Awe. The colors that he named so often, reciting the prism like a litany, were like a mystical rosary adorned with jewels, or waterdrops starring the muddy ground after the storm. Although he was Dutch by birth, Vincent became French through his love of our country. Perhaps he appreciated its climate more than its monuments! He never alluded to our cathedrals, our Gothic art, the Grand Siècle—he even confessed to a loathing of the Sun King. What he loved about France was the warmth of our sunlight, the goodness of our way of life. He was interested in the people of France: he painted and depicted us constantly in our most commonplace routines and our most distinctive landscapes. No matter if his style is not correct—it is alive. Our understanding hearts will know how to heed his words, as when we sense the presence of superior beings even though they speak not a word of our language.

"Isn't it rather intensity of thought than calmness of touch that we're looking for," he wrote to me.

That is what he said about his paintings, seeming to justify their intensity and passion in advance. I also apply this sentiment to his letters. You must feel the thought behind them, the genuine life that is expressed there. "Calmness of touch" is certainly not apparent.

But what intensity! His letters bring us such joy after reading so many exercises in specious literary style, written by people who have nothing to say!

Ardor has no need of elaborate syntax or phraseology when it strives for the moral exaltation of contemplation and creativity.

Note

1 One of them can be found here in Vincent's letters. Consult Letter IX, which speaks, even before I joined Gauguin in Pont-Aven, of my study of the techniques of the Italian and German primitive painters; of the symbolic significance of line and color, which intrigued me, and how Van Gogh dissented by confronting me with Dutch naturalism.

Selected Letters to Émile Bernard

Vincent van Gogh

Arles, on or about Thursday, April 12, 1888

My dear old Bernard,

Thanks for your kind letter and the croquis of your decoration included with it, which I find really amusing. I sometimes regret that I can't decide to work more at home and from the imagination. Certainly—imagination is a capacity that must be developed, and only that enables us to create a more exalting and consoling nature than what just a glance at reality (which we perceive changing, passing quickly like lightning) allows us to perceive.

A starry sky, for example, well—it's a thing that I'd like to try to do, just as in the daytime I'll try to paint a green meadow studded with dandelions.

But how to arrive at that unless I decide to work at home and from the imagination? This, then, to criticize myself and to praise you.

At present I'm busy with the fruit trees in blossom: pink peach trees, yellow-white pear trees.

I follow no system of brushwork at all; I hit the canvas with irregular strokes which I leave as they are, impastos, uncovered spots of canvas—corners here and there left inevitably unfinished—reworkings, roughnesses; well, I'm inclined to think that the result is sufficiently worrying and annoying not to please people with preconceived ideas about technique.

Here's a croquis, by the way, the entrance to a Provençal orchard with its yellow reed fences, with its shelter (against the mistral), black cypresses, with its typical vegetables of various greens, yellow lettuces, onions and garlic, and emerald leeks.

While always working directly on the spot, I try to capture the essence in the drawing—then I fill the spaces demarcated by the outlines (expressed or not) but felt in every case, likewise with simplified tints, in the sense that everything that will be earth will share the same purplish tint, that the whole sky will have a blue tonality, that the greenery will either be blue greens or yellow greens, deliberately exaggerating the yellow or blue values in that case. Anyway, my dear pal, no trompe-l'oeil in any case. As for going to visit Aix, Marseille, Tangier, no fear; if I were to go there, though, it would be in search of cheaper lodgings, &c. Otherwise, I'm convinced that if I worked my whole life, couldn't do as much as half of all that is characteristic of this town alone.

By the way, have seen bullfights in the arenas, or rather, simulated fights, seeing that the bulls were numerous but nobody was fighting them. But the crowd was magnificent, great multicolored crowds. One on top of the other on 2, 3 tiers, with the effect of sun and shade and the shadow cast by the immense circle. Wish you bon voyage—handshake in thought, your friend,

Vincent

Arles, Sunday, July 15, 1888

My dear old Bernard,

Perhaps you'll be inclined to forgive me for not having replied to your letter straightaway, seeing that I'm attaching a small batch of croquis to this one.

In the croquis, the garden, there's perhaps something like "the shaggy carpets of flowers and woven greenery" of Crivelli or Virelli, doesn't much matter. Ah, well—in any case I wanted to reply to your quotations with my pen, but not by writing words. Today, too, I don't have much of a head for discussion; I'm up to my ears in work.

Have made large pen drawings—2—an immense flat expanse of country—seen in bird's-eye view from the top of a hill—vineyards, harvested fields of wheat, all of it multiplied endlessly, streaming away like the surface of a sea toward the horizon bounded by the hillocks of La Crau.

It *does* NOT look Japanese, and it's *actually* the most Japanese thing that I've done.

A microscopic figure of a ploughman, a little train passing through the wheatfields; that's the only life there is in it. Listen, I passed—a few days after my arrival—that place with a painter friend.

There's something that would be boring to do, he said. I said nothing myself, but I found that so astonishing

that I didn't even have the strength to give that idiot a piece of my mind. I go back there, go back, go back again—well, I've done two drawings of it—of that flat landscape in which there was *nothing* but the infinite ... eternity.

Well—while I'm drawing along comes a chap who isn't a painter but a soldier. I say, "Does it astonish you that I find that as beautiful as the sea?" Now he knew the sea—that one. "No—it doesn't astonish me"—he says—"that you find that as beautiful as the sea—but I find it even *more* beautiful than the ocean because it's *inhabited*." Which of the spectators was more the artist, the first or the second, the painter or the soldier—I myself prefer that soldier's eye. Isn't that true?

Now it's my turn to say to you, reply to me quickly this time by return of post—to let me know if you agree to make me some croquis of your Breton studies. I have *a consignment that's about to go off*, and before it clears off I want to do at least another half a dozen subjects in pen croquis for you. Having few doubts that you will do it for yours, I'm getting down to work on my side, anyway, without even knowing if you want to do that. Now, I'll send these croquis to my brother, to urge him to take something from them for our collection.

I've already written to him about that, anyway. But we're working on something that leaves us absolutely without a sou.

The fact is that Gauguin—who has been very ill—is probably going to spend the coming winter with me here

in the south. And there's the fare, which is worrying us. Once here, well, two together spend less than one alone. All the more reason why I'd like to have some things by you here. Once Gauguin's here, we'll try to do something together in Marseille, and will probably exhibit there. Now I'd like to have some things by you too, although without making you lose opportunities for selling in Paris. In any case, I don't believe I'm making you lose them by encouraging you to exchange croquis of painted studies between us. And as soon as I can, we'll do another piece of business as well, but am quite hard up now. What I'm convinced of is that if we exhibit in Marseille, sooner or later Gauguin and I will encourage you to join us.

Thomas bought Anquetin's study in the end—the peasant.

I shake your hand firmly, more soon, and

Ever yours,
Vincent

Arles, between Tuesday, July 17, and Friday, July 20, 1888

My dear old Bernard,

Today I've just sent you another nine croquis after painted studies. In this way you'll see some of the subjects from this nature that inspires *père* Cezanne. Because La Crau near Aix is roughly the same thing as the surroundings of Tarascon and La Crau here. The Camargue is even simpler, because often there's nothing left—nothing but poor soil with tamarisk bushes and the coarse kinds of grass that are to these scanty pastures what halfa grass is to the desert.

Knowing how much you love Cezanne, I thought these croquis of Provence might please you. Not that there are similarities between a drawing by me and by Cezanne; oh, no, no more than between Monticelli and me—but I too love the region that they have loved so much, and for the same reasons of color, of logical design.

My dear old Bernard—by *collaboration* I didn't mean that in my view two or more painters should work on the same paintings. By that I meant, rather, works that are divergent but go together and complement each other. Let's look at the Italian primitives and the German primitives and the Dutch school and the Italians proper, in a word, let's look at painting in its entirety.

Works unintentionally form a "group," a "series." Now then, at present the impressionists too form a group, in spite of all their disastrous civil wars, in which people on both sides try to get at each others' throats with a zeal worthy of a better destination and final goal.

In our northern school there's Rembrandt—head of the school—since his influence is felt by anyone who comes close to him. We see, for example, Paulus Potter painting animals rutting and impassioned in landscapes that are also impassioned—in a thunderstorm, in sunshine, in the melancholy of autumn—whereas before knowing Rembrandt this same Paulus Potter was rather dry and meticulous. There you have two people who go together like brothers, Rembrandt and Potter. And while Rembrandt probably never touched a painting by Potter with his brush, that doesn't alter the fact that both Potter and *Ruisdael* owe to him what's best in them, that something that affects us deeply when we know how to look at a corner of old Holland through their temperament.

And then there's the fact that the material difficulties of the painter's life make collaboration, union among painters, desirable—(just as much as in the days of the guilds of St. Luke).

By safeguarding their material life, by liking each other as pals instead of getting at each others' throats, painters would be happier and anyway less ridiculous, less foolish, and less guilty.

However, I don't insist, knowing that life carries us along so fast that we don't have the time to discuss and

act simultaneously. That's why at present, while the union exists only very incompletely, we're sailing on the high seas in our small and wretched boats, isolated on the great waves of our time.

Is it renaissance, is it decline? We have no way of judging that, for we're too close to avoid being led into error by distortions of perspective. For contemporary events, in our eyes, take on proportions that are probably exaggerated as regards our misfortunes and our merits.

I shake your hand firmly and hope to have news from you soon.

Ever yours,
Vincent

Vincent van Gogh, *The Harvest*, croquis sent to Bernard in July 1888

Vincent van Gogh, *Street in Saintes-Maries-de-la-Mer*, croquis sent to Bernard in July 1888

Arles, Sunday, July 29, 1888

My dear old Bernard,

A thousand thanks for sending your drawings; I very much like the avenue of plane trees beside the sea, with two women chatting in the foreground and the promenaders. Also
 the woman under the apple tree
 the woman with the parasol
then the four drawings of nude women, especially the one washing herself, a gray effect embellished with black, white, yellow, brown. It's charming.

Ah ... Rembrandt ... all admiration for Baudelaire aside—I venture to assume, especially on the basis of those verses ... that he knew more or less nothing about Rembrandt. I've just found and bought here a little etching after Rembrandt, a study of a nude man, realistic and simple; he's standing, leaning against a door or column in a dark interior. A ray of light from above skims his down-turned face and the bushy red hair.

You'd think it a Degas for the body, true and felt in its animality.

But see, have you ever looked *closely* at "*the ox*" or the interior of a butcher's shop in the Louvre? You haven't looked closely at them, and Baudelaire infinitely less so.

It would be a treat for me to spend a morning with

you in the Dutch gallery. All that is barely describable. But in front of the paintings I could show you marvels and miracles that are the reason that, for me, the primitives really don't have my admiration first and foremost and most directly.

But there you are; I'm so far from eccentric. A Greek statue, a peasant by Millet, a Dutch portrait, a nude woman by Courbet or Degas, these calm and modeled perfections are the reason that many other things, the primitives as well as the Japanese, seem to me ... like WRITING WITH A PEN; they interest me infinitely ... but something complete, a perfection, makes the infinite tangible to us.

And to enjoy such a thing is like coitus, the moment of the infinite.

For instance, do you know a painter called Vermeer, who, for example, painted a very beautiful Dutch lady, pregnant? This strange painter's palette is *blue, lemon yellow, pearl gray, black, white.* Of course, in his few paintings there are, if it comes to it, all the riches of a complete palette, but the arrangement of lemon yellow, pale blue, pearl gray is as characteristic of him as the black, white, gray, pink is of Velázquez.

Anyway, I know, Rembrandt and the Dutch are scattered around museums and collections, and it's not very easy to form an idea of them if you only know the Louvre.

However, it's Frenchmen, C. Blanc, Thoré, Fromentin, certain others, who have written better than the Dutch on that art.

Those Dutchmen had scarcely any imagination or fantasy, but great taste and the art of arrangement; they didn't paint Jesus Christs, the Good Lord, and others. Rembrandt though—indeed, but he's the *only one* (and there are relatively few biblical subjects in his oeuvre), he's the only one who, as an exception, did Christs, &c.

And in his case, they hardly resemble anything by other religious painters; it's a metaphysical magic.

So, Rembrandt painted angels—he makes a portrait of himself as an old man, toothless, wrinkled, wearing a cotton cap—first, painting from life in a mirror—he dreams, dreams, and his brush begins his own portrait again, but from memory, and its expression becomes sadder and more saddening; he dreams, dreams on, and why or how I do not know, but just as Socrates and Mohammed had a familiar genie, Rembrandt, behind this old man who bears a resemblance to himself, paints a supernatural angel with a da Vinci smile.

I'm showing you a painter who dreams and who paints from the imagination, and I started off by claiming that the character of the Dutch is that they invent nothing, that they have neither imagination nor fantasy.

Am I illogical? No. *Rembrandt* invented nothing, and that angel and that strange Christ; it's—that he knew them, *felt* them there.

Delacroix paints a Christ using an unexpected light lemon note, this colorful and luminous note in the painting being what the ineffable strangeness and charm of a star is in a corner of the firmament.

Rembrandt works with values in the same way as Delacroix with colors.

Now, there's a gulf between the method of Delacroix and Rembrandt and that of all the rest of religious painting.

I'll write to you again soon. This to thank you for your drawings, which give me enormous pleasure. Have just finished portrait of young girl of 12, brown eyes, black hair and eyebrows, flesh yellow gray, the background *white*, strongly tinged with veronese, jacket bloodred with violet stripes, skirt blue with large orange spots, an oleander flower in her sweet little hand.

I'm so worn out from it that I hardly have a head for writing. More soon, and again, many thanks.

Ever yours,
Vincent

Arles, Wednesday, October 3, 1888

My dear old Bernard,

This time you deserve bigger compliments for the little croquis of the two Breton women in your letter than for the other 6, since the little croquis has a great style. I'm behind myself as far as croquis go, being so totally absorbed these recent superb days with square no. 30 canvases, which wear me out considerably and I intend to use to decorate the house.

You will have received my letter explaining the serious reasons for advising you to try to persuade your father to give you a little more freedom as far as your purse is concerned, should he pay your fare to Arles. I believe that you would repay him through your work. And that way you would stay longer with Gauguin, and leaving to do your service, you would leave for a good artistic campaign. If your father had a son who was a prospector and discoverer of raw gold among the pebbles and on the pavement, your father would certainly not look down on that talent. Now in my opinion, you have absolutely the equivalent of that.

Your father, while he might regret that it wasn't shiny new gold, minted in louis, would set out to make a collection of your finds, and to sell them only for a reasonable price. Let him do the same thing for your paintings

and drawings, which are as rare and as valuable on the market as rare stones or rare metal. That's absolutely true—a painting is as difficult to make as a large or small diamond is to find.

Now while everyone acknowledges the value of a gold louis or a real pearl, unfortunately those who set store by paintings and believe in them are few and far between. But they do exist. And in any case, there's nothing better to do than to wait without getting impatient, even if one has to wait for a long time. On your side, think a little about what I'm telling you about the cost of living here, and should you have a strong wish to come to Arles with Gauguin and me, be sure to tell your father that with a little more money you would make much better paintings.

The idea of making a kind of freemasonry of painters doesn't please me hugely; I deeply despise rules, institutions, &c., in short, I'm looking for something other than dogmas, which, very far from settling things, only cause endless disputes.

It's a sign of decadence. Now, as a union of painters exists so far only in the form of a vague but very broad sketch, then let's calmly allow what must happen to happen.

It will be better if it crystallizes naturally; the more one talks about it, the less it comes about. If you wish to support it, you have only to continue with Gauguin and me. It's in progress, let's not talk any more; if it must come it will come about without big negotiations but through calm and well-thought-out actions.

As regards the exchanges, it's precisely because I've often had occasion to hear mention in your letters of Laval, Moret, and the other young man that I have a great desire to get to know them. But—I don't have 5 dry studies—will have to add at least two slightly more serious attempts at paintings, a portrait of myself and a landscape angry with a nasty mistral.

Then I would have a study of a little garden of multi-colored flowers.

A study of gray and dusty thistles, and lastly a still life of old peasants' shoes. And a small landscape of nothing at all, in which there's nothing but a bit of an expanse. Now, if these studies aren't found pleasing, and if one or other preferred not to take part, all you have to do is keep those that are wanted and return with the exchanges those that aren't wanted. We're in no hurry, and in exchanges it's better on both sides to try to give something good.

If it's dry enough to be rolled up after being exposed to the sun tomorrow, I'll add a landscape of men unloading sand, another project and attempt at a painting, in which there's a more fully developed sense of purpose.

I can't send a repetition of the night café yet because it hasn't even been started, but I'm very willing to do it for you, but once again, it's better on both sides to try to exchange good things than to do them too hastily.

The artistic gentleman who was in your letter, who resembles me—is that me or somebody else?

He certainly looks like me as far as the face is concerned, but in the first place I'm always smoking a pipe, and then, having vertigo, I have an unspeakable horror of sitting like that on sheer crags beside the sea. So if that's meant to be my portrait, I protest against the above-mentioned improbabilities.

The decoration of the house absorbs me terribly. I dare to believe that it would be quite to your liking, although it's very different from what you do, of course. But just as you spoke to me in the past about paintings that would depict, one *flowers*, the other *trees*, the other *fields*.

Well, I have the *Poet's garden* (2 canvases) (among the croquis you have the first idea for it, after a smaller painted study that's already at my brother's).

Then *The starry night*, then *The vineyard*, then *The furrows*, then the view of the house could be called *The street*, so unintentionally there's a certain sequence.

Well, I'll be very, very curious to see studies of Pont-Aven. But for yourself, give me something fairly worked up. It will work out, anyway, because I like your talent so much that I'd be very pleased to make a small collection of your works, bit by bit.

For a long time I've been touched by the fact that Japanese artists very often made exchanges among themselves. It clearly proves that they liked one another and stuck together, and that there was a certain harmony among them and that they did indeed live a kind of brotherly life, in a natural way and not in the midst of in-

trigues. The more we resemble them in that respect, the better it will be for us. It seems, too, that those Japanese earned very little money and lived like simple laborers. I have the *reproduction* (Bing publication) of a Japanese drawing: A single blade of grass. What an example of *awareness*—you'll see it one day. I shake your hand firmly.

Ever yours,
Vincent

Arles, on or about Friday, October 5, 1888

My dear old Bernard,

The consignment Gauguin and you sent arrived at almost the same time as my studies went off. I was delighted, it really warmed my heart to see the two faces again. As for your portrait—you know—I like it very much—actually I like everything that you do, as you know—and perhaps nobody *before* me has liked what you do *as much* as I do.

I really urge you to study the portrait; make as many as possible and don't give up—later we'll have to attract the public through portraits—in my view that's where the future lies. But let's not get sidetracked into hypotheses now. Because it's up to us next to thank you for the collection of rough sketches entitled *At the brothel*.

Bravo! The woman washing herself and the one who says "I'm second to none when it comes to taking it out of a man" are the best, it seems to me. The others are grimacing too much—and most of all, are too vague, too little flesh and bone properly built up.

It doesn't matter; it's already something altogether new and interesting, and the rest, too—at the brothel—yes, that's what needs to be done, and I assure you that I for one almost envy you this bloody good opportunity you have to go in there in uniform. Which those good lit-

tle women adore. The poem at the end is really beautiful; stands up better than some of the figures. What you want, and what you say you believe, you say well and resonantly.

Write to me when you're going to be in Paris—the thing is that I've already written you a thousand times that my night café *isn't a brothel*, it's a café where night prowlers cease to be night prowlers, since, slumped over tables, they spend the whole night there without prowling at all. Occasionally a whore brings her fellow there. But arriving there one night I came across a little group of a pimp and a whore who were making up after a quarrel. The woman was pretending to be indifferent and haughty, the man was tender. I started to paint it for you from memory—on a little no. 4 or no. 6 canvas—now if you're leaving soon—I'll send it to you in Paris; if you're staying longer, say so, I'll send it to you in Pont-Aven. I couldn't add it to the consignment, it was nowhere near dry enough.

But I don't want to sign this study, because I never work from memory—there will be color in it, which will suit you, but to repeat, here I'm doing a study for you that I would prefer not to do. I mercilessly destroyed an important canvas—a Christ with the angel in Gethsemane—as well as another one depicting the poet with a starry sky—because the form hadn't been studied from the model beforehand, necessary in such cases—despite the fact that the color was right.

If the study I'm sending you in exchange doesn't suit you, just look at it a little longer.

I had the devil's own job to do it with an irritating mistral (like the study in red and green, as well). Well, despite the fact that it wasn't painted as fluently as the old mill—it's more delicate and more intimate. You see that all of this is perhaps not at all—impressionist—well, too bad, I can't do anything about it—but I do what I do with an abandonment to reality, without thinking about this or that. Goes without saying that if you preferred another study from the batch to the Men unloading sand, you could take it and remove my dedication if someone else wants it. But I believe that one will suit you once you've looked at it a little longer.

If Laval, Moret, and the other one agree to make exchanges with me, perfect, but on my side I'd be especially satisfied if they wanted to do their portraits for me.

You know, Bernard, it always seems to me that if I want to do studies of brothels I'd need more money than I have; I'm not young or womanizer enough for them to pose for me for free. And I can't work without a model. I'm not saying that I don't flatly turn my back on reality to turn a study into a painting—by arranging the color, by enlarging, by simplifying—but I have such a fear of separating myself from what's possible and what's right as far as form is concerned.

Later, after another ten years of studies, all right, but in very truth I have so much curiosity for what's possible and what really exists that I have so little desire or courage to search for the ideal, in so far as it could result from *my* abstract studies.

Others may have more clarity of mind than I for abstract studies—and you might certainly be among them, as well as Gauguin and perhaps myself when I'm old.

But in the meantime I'm still living off the real world. I exaggerate, I sometimes make changes to the subject, but still I don't invent the whole of the painting; on the contrary, I find it ready-made—but to be untangled—in the real world.

But you'll probably find these studies ugly, I don't know. In any case, neither you nor anyone else should do an exchange grudgingly.

My brother writes that Anquetin's back in Paris; I'm curious to know what he's made. When you see him you'll give him my warm regards.

The house will seem more lived-in now that I'll see the portraits in it.

How happy I would be to see you there yourself this winter; it's true that the trip costs rather a lot. Nevertheless, may one not risk those expenses by taking one's revenge by working? Work's so difficult in the north in winter. Here, too, perhaps; I've hardly had the experience yet and it remains to be seen.

But it's damned useful to see the south, where life is lived more in the open air, in order to understand the Japanese better.

And that touch of the haughty and the noble that certain places have down here will suit your book very well. In the Red sunset, the Sun should be imagined higher, outside the painting, let's say just at the level of the

FRAME. Because it so happens that an hour, an hour and a half before it sets, the things on the earth still keep their colors like that. Later the blue and the violet color them darker, as soon as the sun sends out rays that are more horizontal. Thanks once again for what you sent me, it really warmed my heart.

And a good handshake in thought, and write to me the day of your departure so that I know when you'll be in Paris; address in Paris still 5, avenue de Beaulieu, isn't it?

Ever yours,
Vincent

ACKNOWLEDGMENTS

I would like to thank the staff at the Morgan Library and Museum in New York, in particular, the curator Jennifer Tonkovich, for allowing me access to Vincent van Gogh's original letters to Émile Bernard. As always, I am grateful to my colleagues at the Van Gogh Museum in Amsterdam, especially the researcher Jost van der Hoeven. The literature on Bernard is relatively small, compared with the mountain of material on Van Gogh. I would like to pay tribute to the key Bernard publications by Nienke Bakker, Anne-Birgitte Fonsmark, Dorothee Hansen, Armand Israël, Leo Jansen, Fred Leeman, Hans Luijten, Jean-Jacques Luthi, Neil McWilliam, Anne Rivière, MaryAnne Stevens, and Bogomila Welsh-Ovcharov. Finally, at David Zwirner Books, I would like to thank Luke Chase, Doro Globus, Elizabeth Gordon, Jessica Palinski Hoos, and Lucas Zwirner.

VINCENT VAN GOGH (1853–1890) produced nearly nine hundred paintings and more than eleven hundred works on paper during his ten-year career. He first developed his artistic sensibility while working for the art dealer Goupil in The Hague, London, and Paris. Van Gogh disliked the art trade, so he pursued opportunities to teach, sell books, and do missionary work before finally setting out to become an artist himself. He briefly enrolled at the Académie royale des Beaux-Arts in Brussels before traveling to study independently. Eventually, he moved to Paris to live with his brother Theo, who introduced him to Camille Pissarro, Georges Seurat, and other members of the impressionist and post-impressionist groups. During this period, he began to develop the style of broken brushwork and use of pure color that he would become known for. After two years in Paris, Van Gogh moved to Arles, where he hoped to establish a community of like-minded artists. Though he was never able to realize this dream, he continued to develop his signature style of painting, maintaining his creative practice even during the year he spent in an institution outside Saint-Rémy-de-Provence. By the time of his death, in July 1890, his work was beginning to gain critical acclaim, and by the start of World War I, his reputation as a pioneer of modern art was beginning its trajectory toward making him one of the world's best-known artists.

ÉMILE BERNARD (1868–1941) was a French painter and writer known for his contributions to cloisonnism—a post-impressionist style defined by flat plains of bold color and distinct outlines—and his friendships with Vincent van Gogh, Paul Gauguin, Odilon Redon, and Paul Cezanne. He began his studies at the École des Arts Décoratifs and spent time in the studio of Fernand Cormon, but he was eventually dismissed for his overly expressive style. Undeterred, he left Paris to explore Brittany on foot, where he met Paul Gauguin in the artists' colony of Pont-Aven. Although still young, Bernard began developing theories about art and aesthetic goals for his own work, ideas that contributed to the emergence of the cloisonnist and synthetist movements. He was also a prolific writer of art criticism and poetry: he published his correspondence with Van Gogh and other artists and founded and edited the review *La Rénovation esthétique*. Though less well known than works by the artists he promoted in his writing, his paintings are held in the collections of major museums.

MARTIN BAILEY is a London-based Van Gogh specialist. His recent books include *The Sunflowers Are Mine: The Story of Van Gogh's Masterpiece*; *Studio of the South: Van Gogh in Provence*; *Living with Vincent van Gogh: The Homes and Landscapes that Shaped the Artist*; *Starry Night: Van Gogh at the Asylum*; and *Van Gogh's Finale: Auvers and the Artist's Rise to Fame*. He has curated a number of Van Gogh exhibitions and is a correspondent for *The Art Newspaper*.

"Ekphrasis" is traditionally defined as the literary representation of a work of visual art. One of the oldest forms of writing, it originated in ancient Greece, where it referred to the practice and skill of presenting artworks through vivid, highly detailed accounts. Today, "ekphrasis" is more openly interpreted as one art form, whether it be writing, visual art, music, or film, that is used to define and describe another art form, in order to bring to an audience the experiential and visceral impact of the subject.

The *ekphrasis* series from David Zwirner Books is dedicated to publishing rare, out-of-print, and newly commissioned texts as accessible paperback volumes. It is part of David Zwirner Books's ongoing effort to publish new and surprising pieces of writing on visual culture.

OTHER TITLES IN THE *EKPHRASIS* SERIES

My Friend Van Gogh
Émile Bernard

Published by
David Zwirner Books
520 West 20th Street, 2nd Floor
New York, New York 10011
+ 1 212 727 2070
davidzwirnerbooks.com

Editor: Elizabeth Gordon
Editorial coordinator: Jessica
Palinski Hoos
Copy editor: Chris Mooney
Proofreader: Livia Tenzer

Design: Michael Dyer / Remake
Production manager: Luke Chase
Color separations: VeronaLibri,
Verona
Printing: VeronaLibri, Verona

Typeface: Arnhem
Paper: Holmen Book Cream, 80 gsm

Publication © 2024
David Zwirner Books

Introduction © 2024
Martin Bailey

The texts by Émile Bernard were
translated from the French by
Elizabeth G. Heard. Translation
© 2024 David Zwirner Books

The letters by Vincent van Gogh are
reprinted with permission from
*Vincent van Gogh: The Letters, the
Complete Illustrated and Annotated
Edition*, edited by Leo Jansen,
Hans Luijten, Nienke Bakker. © 2009
Van Gogh Museum, Amsterdam;
Huygens ING, Amsterdam

p. 5: Van Gogh Museum,
Amsterdam (Vincent van Gogh
Foundation)
p. 29: Bibliothèque nationale
de France
p. 123: National Gallery of Art,
Washington, DC. Collection of
Mr. and Mrs. Paul Mellon
p. 124: The Metropolitan Museum
of Art, New York. Bequest of Abby
Aldrich Rockefeller, 1948

ISBN 978-1-64423-119-7

Library of Congress
Control Number: 2023950503

Printed in Italy